Carla Cecilia

A VIEW OF THE
VATICAN

EDIZIONI MUSEI VATICANI

© Copyright Edizioni Musei Vaticani 2007
I edition: 2001
Updated reprint: 2007

Editorial direction:

Francesco Riccardi, Administrator of the Vatican Museums

Editing:

Georgina Bernett, Carla Cecilia, Yorick Gomez Gane, Roberto Zagnoli

Graphic lay-out:

Alessandra Murri

Translation:

Speer Ogle, Henry Mc Connachie

Photographs:

Photographic Archive of the Vatican Museums, excepting:
Biblioteca Apostolica Vaticana (pp. 16, 17, 20, 21, 27); Archivio Segreto Vaticano (pp. 15, 17); Archivio Fabbrica di San Pietro in Vaticano (pp. 19, 22, 24-25, 28, 29, 31, 33, 34, 35, 36, 37, 38, 39, 93); Capitolo di San Pietro (pp. 40, 41); Archivio Fotografico Cocacolor (pp. 6-7, cover); Pubbli Aer Foto (pp. 8-9); Archivio Fotografico Alinari (p. 26).

Photolithography:

Studio Lodoli, Rome

Photocomposition and printing:

Vatican Press, Vatican City State 2007

ISBN 978-88-8271-639-4

INDEX

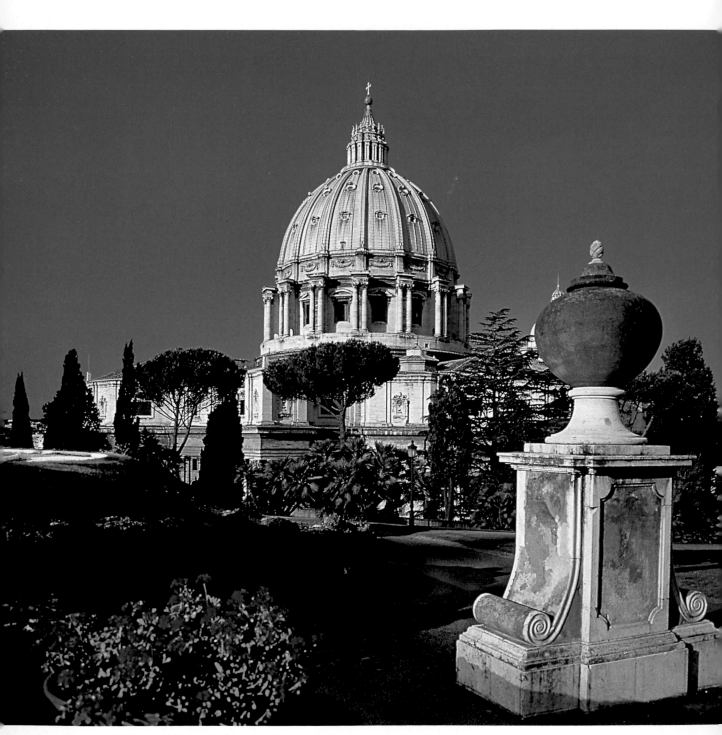

View of the dome of St. Peter's from the Vatican Gardens.

Preface

The dome of St. Peter's Basilica is the natural landmark for anybody visiting Rome. Although the Vatican hill on which the church is built, on the same site as the previous church constructed by the Emperor Constantine, is not included among the traditional Seven Hills, it is today the most important and renowned of the Roman hills. The name of the hill ended up indicating the whole building complex which, together with the Basilica, forms one of the smallest States in the world, with 44 hectares of territory in all.

Even though the massive shape of the Basilica's dome, projected by Bramante and completed by Michelangelo, seems to be pointing at the sky, its true aim is to enclose a precious tomb, as in a jewel box. A humble and unadorned tomb, but one that is very rich in significance. Tradition, supported today by extensive evidence, asserts that the small loculus is the burial place of Peter, the Apostle to whom the Lord entrusted the task of presiding charitably over the life of the Church. Therefore, the Basilica points to this tomb and preserves it as the center of the Vatican, the symbolic "stone" upon which the Church is built. Those who today, as yesterday, travel to Rome moved by faith, walk devotedly towards that tomb. But their journey is not only a pilgrimage of remembrance. Even though Peter, as an historical figure, belongs to the past, his relevance to the present day is clearly evidenced in his successor, the Pope of Rome.

If then the eye of the visitor moves from the huge Basilica to the surrounding buildings, he realizes that what he's looking at is simply "the Church and the Pope's home" and that by being so it is, in a certain sense, a home for everybody. This particular "home" was conceived and embellished by the greatest artists of all time. Its historical, cultural and artistic treasures can be considered the historical heritage of all mankind. This home is not only a source of amazement, but also of familiar attraction. St. Peter's colonnade itself, welcoming the pilgrim with its open arms, contributes to this warm friendly atmosphere.

The book you are about to read was conceived in such an atmosphere. Its pages do not claim to be overly detailed or exhaustive, and the language is simple and easy to read. The title itself "A View of the Vatican", tells us that this guidebook will accompany the visitors in a very unobtrusive way. The many illustrations enriching the book are aimed at hinting ideas that perhaps words cannot express. A book to be read and looked at; a book intended to help the visitor cherish a treasure which does not belong to the Church alone, but to all mankind.

Edmund Casimir Card. Szoka
President Emeritus of the Pontifical Commission
for the Vatican City State

INTRODUCTION

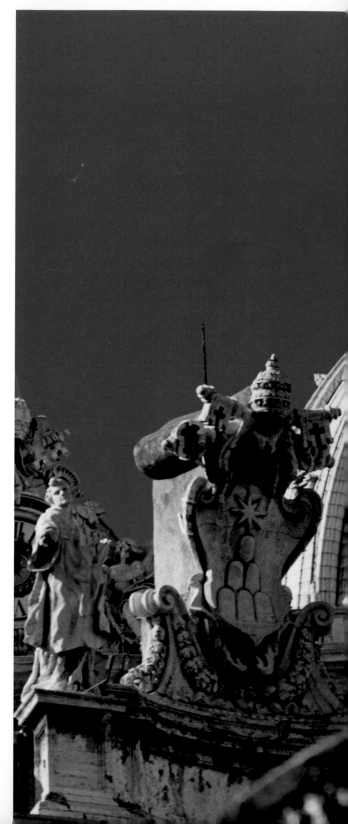

Tu es Petrus et super hanc petram aedificabo ecclesiam meam ("Thou art Peter and upon this rock I will build my church", Mt. 16,18).

From these simple words pronounced by Jesus to the Apostle Simon of Bethsaida, better known to everyone by the name the Master gave him, springs the vital lymph that makes the Vatican an irresistible centre of attraction that knows no end.

The entire complex of the Vatican in fact draws its origins and its strength from the nucleus upon which and for which it was built: the tomb of Peter, martyr of the faith and the first vicar of Christ on earth and whose successor is the Pope.

The unique and unrepeatable character of this multiform structure was perfectly understood by the then Monsignor Giovanni Battista Montini, the future Pope Paul VI, who wrote in the preface to a publication on the Vatican:

The Vatican is not only a complex of monumental buildings that can be of interest to the artist; nor is it only a magnificent emblem of past centuries that can interest the historian; nor is it only a treasure-trove of bibliographical and archaeological treasures that can interest the scholar; nor is it only a famous museum containing sublime works of art of interest to the tourist; nor is it only a temple sacred to the martyrdom of the Apostle Peter that can interest the faithful. The Vatican is not only the past: it is the dwelling place of the Pope, of an authority still living and working. The Vatican is not only what one sees: it is the expression of a thought, of a design, of a programme that aims to touch mankind as a whole, and still has in itself the secret of immanent youth, of perennial actuality.

(G.B. Montini, *Introduction to Vaticano*, edited by G. Fallani and M. Escobar, Florence, Sansoni, 1946, p. VIII)

Overleaf. *Panoramic view of St. Peter's Square. On the left of the basilica is the Palazzo del Sant'Uffizio and the Aula delle Udienze (or Paul VI Hall). On the right one sees the Cortile di S. Damaso by the Apostolic Palace, the Pope's residence. (Photo Pubbli Aer Foto).*

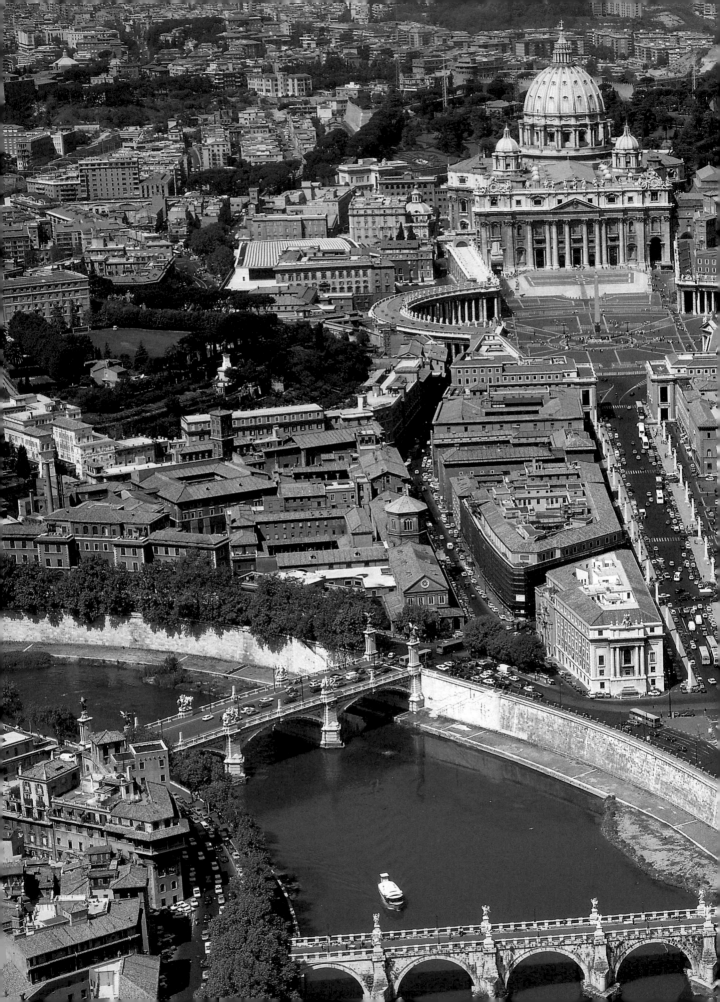

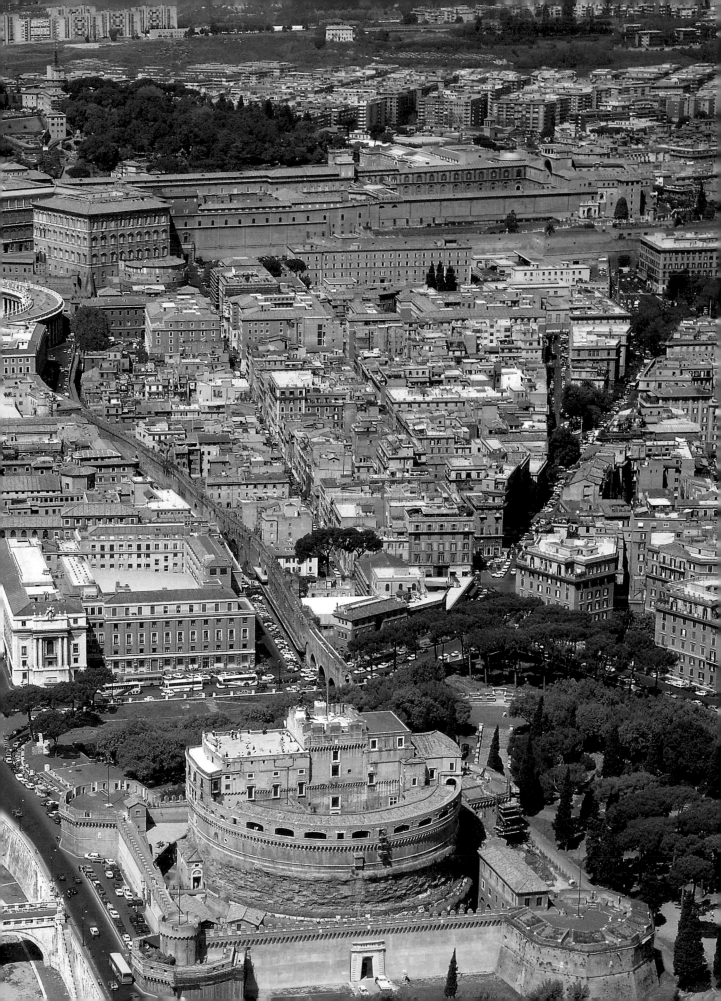

THE VATICAN CITY STATE

The *Vatican City* is an independent and sovereign State (the smallest in the world) which was founded on the 11th of February 1929 with the Lateran Treaty drawn up between Italy and the Holy See to enable the latter "to proceed with due freedom and independence in the pastoral governance of the Diocese of Rome and of the Roman Catholic Church in Italy and throughout the world. (art. 26)"[1]

Its territory, which extends over a total of 44 hectares, is situated within the urban area of the city of Rome; its borders are outlined by the sixteenth century surrounding walls and and at St. Peter's Square by the broad sash of travertine marble on the ground that connects the extremities of the two wings of Bernini's colonnade. There are five entrances guarded by the *Pontifical Swiss Guards* and the *Corps of Gendarms* of Vatican City State. The Swiss Guards remain the Vatican's military corps since their establishment by Pope Julius II at the beginning of the sixteenth century. The *Corps of Gendarms* is a civil organ that serves as a police force in charge of security, criminal investigation, and street patrol inside the Vatican.

The Supreme Pontiff is the absolute sovereign of the State which has its own flag (consisting of two vertical bands of gold [hoist side] and white with the crossed keys of Saint Peter and the Papal Tiara centered in the white band), mints its own coins, issues its own postage stamps, provides, among other things, postal and banking services, and also has its own radio and railway stations. About 750 people live there, a little over half of whom have Vatican citizenship while the rest enjoy permanent or temporary residence. The State's form of government is an elective absolute monarchy: the Pontiff exercises legislative, executive and judicial power through a number of bodies. The legislative power is by law entrusted to the the *Pontifical Commission for the Vatican City State* which is comprised of a number of Cardinals that the Supreme Pontiff appoints for a period of five years. The Pontiffs entrusts his executive powers to the President of the Pontifical Commission who, due to his appointment, serves as the President of the Governatorate. The judicial powers are entrusted to diverse judicial bodies.

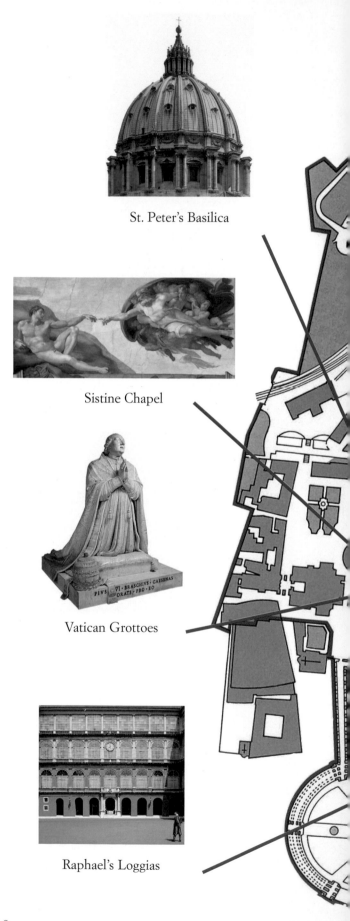

St. Peter's Basilica

Sistine Chapel

Vatican Grottoes

Raphael's Loggias

Governatorato

Casina di Pio IV
(Vatican Gardens)

Apostolic Palace

Cortile della Pigna

THE GOVERNATORATE (GOVERNORSHIP)

The Governatorate, "is a complex of organisms that deal with the executive powers in the Vatican City State" (law, 16/7/2002). It consists of the *President of the Governatorate* who, enjoying delegated executive powers, directs the overall administration of the State; the *Secretary General* who carries out the directives of the President and coordinates the activities of the Direction and other Organisms; and the *Vice Secretary General* who assists the President and Secretary General and supervises the activities and correspondence related to the running of the State. Each of these offices is by papal appointment and for a five year term.

The Governatorate's organisms are the *Directorates* and other *Central Departments*. The responsibility of the *Managing Department of the Museums* is to care for and preserve the artistic patrimony belonging to the Holy See. This Department consists of various *Department Sections* organised on the basis of the nature and period of the patrimony in their care; the *Restoration Laboratory*, and the *Consulting Room for Scientific Research*.

The *Office for the Sales of Publications and Reproduction* lies inside the Museums and works in strict collaboration with the Managing Department. It

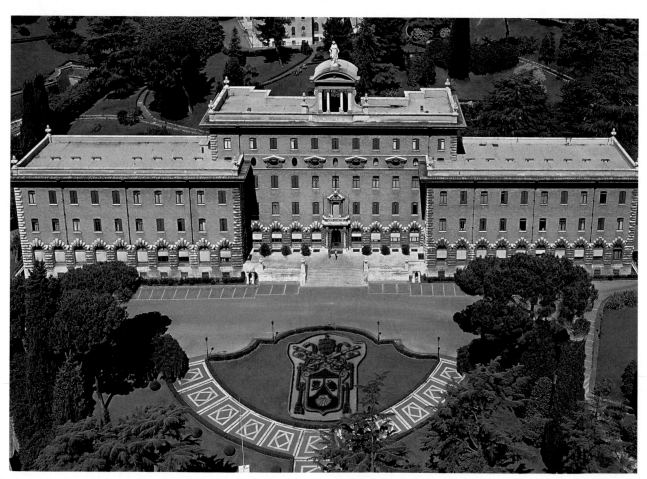

Aerial view of the Palazzo del Governatorato. Planned by the architect G. Momo in the 1920's the grandiose building, immersed in the green of the Vatican Hill, is the headquarters of the Pontifical Commission for the Vatican City State.

provides for the planning, realization and distribution of publications and reproductions inspired by the patrimony of the Vatican Museums. The *Department for Technical Services* is charged with the upkeep of the Vatican's patrimonial real estate (*Maintenance Services*), with the management of various technological installations within the territory (*Services for Laboratories and Installations*), the upkeep of the Vatican Gardens along with their fountains and roads (*Giardini Vaticani*), as well as with resolving any problems that might arise in any of these activities (*Central Services*). The *Department for Economic Services* deals with the purchase of food items and other provisions (clothing, tobacco and gasoline) and their sales at various modern buildings locations inside Vatican territory (the supermarket, the warehouse and the tobacco shop). The *Department for Health Services* is responsible for health care and hygiene in the territory as well as ensuring adequate medical and health assistance to citizens and residents of the State as well as for State employees and those of the Holy See. The *Department for General Services* includes the *Office of Transitory Merchandise* which serves as the Customs Office for the State, the *Furnishing Office which* is responsible for providing the furnishings for places set for Liturgical Celebrations or for the Supreme Pontiff's Ceremonies and Audiences, and the *Motor Vehicle Office* which registers Vatican vehicles and purchases and maintains the fleet of cars belonging to the State. The *Department for the*

Pontifical Villas runs and maintains the palaces and gardens at the Pontifical residence at Castel Gandolfo (55 hectares), an extraterritorial area used as the Pontiff's summer residence. The *Vatican Observatory* is housed at the pontifical palace of Castel Gandolfo. It carries out scientific research in the fields of astronomy and astrophysics. The *Accounts Department* supervises accountancy and bookkeeping activities. The *Department for Security Services and Public Safety* is under the supervision of the head of Corps of the Gendarmes which acts in the capacity ascribed to the police, and the Fire Department which is responsible to immediate action and prevention of fire. The Postal and Telegraph services form part of the *Department for Telecommunications*. The former is in charge of mail service, while the latter is responsible for the telephone service. The *Central Services* are comprised of the *Legal Department*, the offices for Personnel, the Civil State, Vital Statistics, the Notary, the Philatelic, the Numismatics, the Information Systems, Pilgrims, Tourism, and the State Archives. All of these offices are connected with the exercise of the executive powers that are enjoyed by the Cardinal President.

In the Palazzo del Belvedere, near the supermarket, is the *Vatican Pharmacy* that was established in 1874 and entrusted to the Brothers of St. John of God. It is renowned for its ability to provide a vast array of medicines (often unobtainable in Italy) as well as cosmetic and perfume items.

INSTITUTIONS CONNECTED WITH THE HOLY SEE

Within the territory of the Vatican there is also the *Tipografia Vaticana* (Printing Press). Set up in 1587 in accordance with the wishes of Pope Sixtus V, it was enlarged and given more power between the end of the nineteenth and the beginning of the twentieth century by Popes Leo XIII and Pius X. Completely restructured by Pope John Paul II in 1991, the Tipografia carries out extensive editorial activities using state of the art equipment. To a *sezione segreta*, composed of people who are morally and professionally qualified and who have solemnly sworn to keep the most absolute secrecy regarding the office, is entrusted the printing of official documents of the Holy See, the Roman Curia and the Vatican City State.

Also printed by the Vatican printing press is the *Osservatore Romano*, the daily political and religious newspaper, the official voice of the Holy See. The newspaper, which first came out on the 1st of June, 1861, "has the task of faithful adherence to the thinking of the Pope, head and pastor of the universal Church": it reproduces exactly the Holy Father's discourses, reports on the activities of the Holy See, and the main events concerning the Church in Italy and throughout the world. The daily edition is published in Italian but there are also weekly editions in English, French, Spanish, Portuguese and German.

From the Cortile del Belvedere one enters the *Biblioteca Apostolica Vaticana* (Vatican Apostolic Library), one of the most prestigious bibliographical complexes in the world. Open only to professionally qualified scholars, it preserves a patrimony of inestimable cultural value made up of about 150,000 manuscript volumes, 8,000 incunabula and almost two million printed books. If it is to Pope Sixtus V (1585-1590) that we owe the construction of a new building (1587-1589; cf. p. 46) which still houses the collection, the founder was undoubtedly Pope Nicholas V (1447-1475). This Pope, a pas-

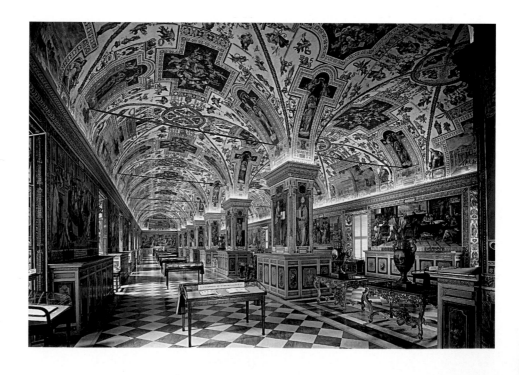

Salone Sistino. Sixtus V had this spacious two-naved hall built by Domenico Fontana in the years between 1587 and 1589, thus transversely dividing in two the Cortile del Belvedere, which Bramante (1444-1514) had planned as a single undivided space uniting the papal Palace to the south and the Palazzetto of Innocent VIII to the north.

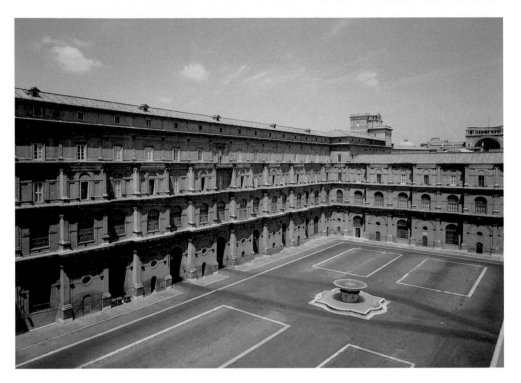

sionate humanist, known with the baptism name of Tommaso Parentucelli, consistently added to the pontifical collection, acquiring manuscripts and illuminated codices on the Western and Eastern markets. The real founder of the Vatican Apostolic Library is however, Sixtus IV (1471-1484) who with the bull *Ad decorem militantis Ecclesiae* (1475) sanctioned the official founding of the library, founded "to increase the Catholic faith for the use of scholars and the splendour of the Roman Pontiff" and endowed from his own means a fixed headquarters with librarian Bartolomeo Sacchi, known as Platina, a noted humanist and historian of his time.

The north-west wing of the Cortile del Belvedere houses another important and prestigious institution, The *Archivio Segreto Vaticano* (Vatican Secret Archives). If it is only with Paul V (1605-1621) that one can speak about the foundation (1610) of a modern archive conceived as an autonomous institution with its centre in the rooms it still occupies today, the history of the archives of the Roman Pontiffs has its roots in the very earliest days of the Church, closely associating itself with her origin, activities and development. Open for consultation by scholars since 1880, by Leo XIII (1878-1903), the Secret Archives, "destined to contain all the acts and documents that concern the governing of the universal Church (motu proprio *Fin dal principio* of Leo XIII of the 1st of May 1884), preserves about 8,500 documents from the most ancient, dating back to the 9th century, to the more recent of the second half of the 19th century.

Another important organisation, that was set up for the custody and administration of the capital destined for works of religion or of charity is the *Istituto per le Opere di Religione* (Institute for the Works of Religion), better known by its acronym (IOR). Set up in 1942 by Pope Pius XII, it was restructured in 1990 by Pope John Paul II who wished to give it a new image with the aim of upgrading its structures and activities. This is a financial organisation which has been described as a "central board" of the Church inasmuch as it is part of the Roman Curia whose charge is the spiritual governing of the Universal Church.

HISTORICAL ORIGINS OF THE VATICAN

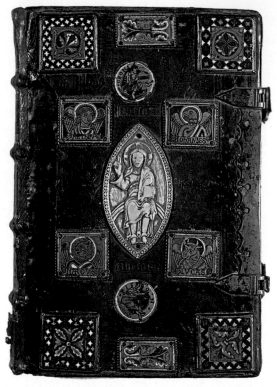

The term "Vatican" derives its roots from the ancient name of the wide area on the right bank of the Tiber, partly flat (*ager Vaticanus*) and partly hilly (mons Vaticanus) which throughout antiquity was considered too far out to be properly inhabited.

In imperial times the area became the favoured location of famous villas, endowed with splendid gardens, such as those of Agrippina the Elder, (*horti Agrippinae*), the mother of the Emperor Caligula (37-41 A.D.), and that of the Domizi family, which was then inherited by the Emperor Nero (*horti Neronis*). Caligula had a great circus built for his private use in the gardens of his mother's villa, which was later extended by Nero (54-68 A.D.), on the central spine of which was raised an impressive obelisk (the one standing today in the centre of St. Peter's Square) brought from Heliopolis in Egypt.

This was the actual spot where, in the years after 64 A.D.[2] the brutal persecution of Christians by the Emperor Nero, of whom the Apostle Simon Peter was also a victim, took place.

Here, in fact, *iuxta obeliscum* or "near the obelisk", St. Peter was crucified upside down, as ancient tradition testifies, and buried in a simple rock tomb in the pre-existing necropolis which extended a little towards the north, along the Via Cornelia.

The binding of the Ravensberg Lectionary, codex Pal. Lat. 502. (Photo Biblioteca Apostolica Vaticana).

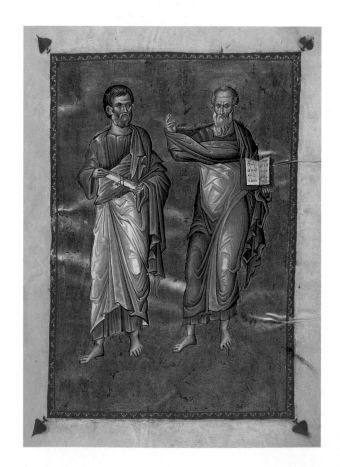

Right. *A miniature of the codex of the Acts of the Apostles, Epistole (Vat. Gr. 1208, fol. 2r), depicting St. Peter and St. John. (Photo Biblioteca Apostolica Vaticana).*

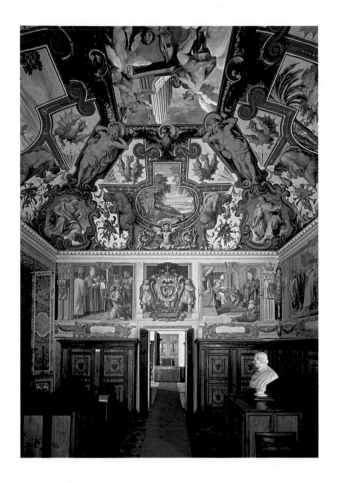

Left. *Vatican Secret Archives. Second room of the main floor with the marble bust of Father A. Thenier, Prefect from 1855 to 1870. The fresco above the doorway reproduces the coat of arms of Cardinal Scipio Borghese, Librarian from 1609 to 1618. (Photo Archivio Segreto Vaticano).*

Below, left. *One of the most precious examples from the celebrated collection of gold seals of the Vatican Secret Archives: the seal of Federico Barbarossa (1164). (Photo Archivio Segreto Vaticano).*

Below, right. *A page from the codex of Virgilio Romano, Vat. Lat. 3867, fol. 3v. (Photo Biblioteca Apostolica Vaticana).*

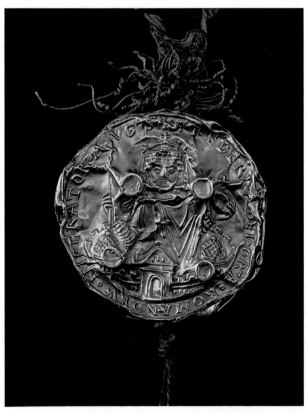

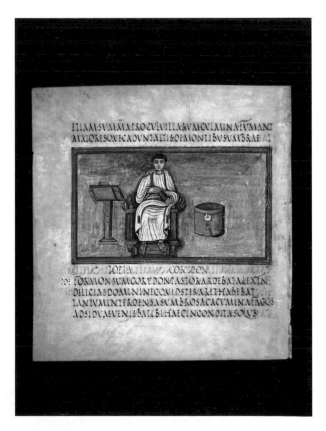

ST. PETER'S BASILICA

1. THE CONSTANTINIAN BASILICA

To honour the tomb of the Prince of the Apostles in a worthy manner, the Emperor Constantine (306-337 A.D.) gave orders for the construction of an impressive basilica in the form of a Latin Cross[3] subdivided into five naves, which was completed within six or seven years, around the year 330 A.D. So that the tomb of Peter could constitute the fulcrum of the new construction it was necessary to burrow into the hill and to bury a good part of the necropolis which was then still in use. Legend recounts that it was the emperor himself who with his own hands began the excavation of the foundations, filling twelve baskets of earth, one for each of the Apostles.

Of the Constantinian basilica, replaced by the present one from 1506 onwards, there remains only a good written and iconographical documentation[4]. It was preceded by a wide quadrilateral portico with at its centre a fountain for ablutions in the form of a monumental pine cone, the same one we can still see today in the Courtyard of the Pine Cone in the Vatican Museums. The façade, splendidly decorated with mosaics, depicted Christ and the four evangelists and this is also borne witness to by the fresco of the *Incendio di Borgo*, in the *Stanza* of the same name by Raphael in the Pontifical Apartment. The interior of the basilica was embellished with splendid marble and mosaic decorations and by many funerary monuments of the popes who were buried close to the tomb of the Apostle.

2. THE PRESENT BASILICA

The exterior
St. Peter's Basilica as we see it today is the fruit of the laborious reconstruction of the old Constantinian Basilica, replaced after 120 years of uninterrupted work (1506-1626), under a many Popes (eighteen)

Reconstruction of the Circo Vaticano. The area where the circus of Caligula and Nero was built, scene of the first persecution of Christians in which the Apostle Peter was martyred, is today occupied by the southern side of St. Peter's Basilica.

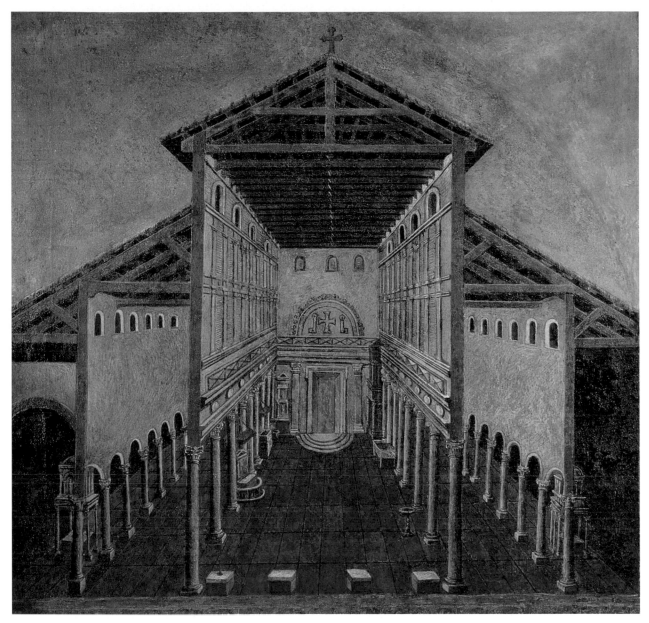

Sectional view of the Constantinian Basilica from a fresco (1616) by Giovan Battista Ricci from Novara, transferred on canvas, in the "Bocciata" Chapel in the Vatican Grottoes. (Photo Archivio Fabbrica di San Pietro in Vaticano).

and architects (twelve), in a time known as the "Building of St. Peter's".

Already during the reign of Pope Nicholas V (1447-1455) Constantine's Basilica was more or less damaged by time. For this reason a total reconstruction, planned by Leon Battista Alberti and Bernardo Rossellino, was promptly started but interrupted after a short time on the death of the pontiff.

The start of the true reconstruction of the basilica is due to the energetic activities of Pope Julius II (1503-1513) who commissioned Donato Bramante to construct the new church. This architect from Urbino who because of this assignment earned the nickname of "Mastro Ruinante" (despoiling master), planned a basilica in the form of a Greek Cross[5], with a spacious hemispherical cupola placed over the central body and four minor cupolas between the arms of the cross. The work which started in April 1506, on the death of Julius II (1513) and of Bramante (1514) was halted at the

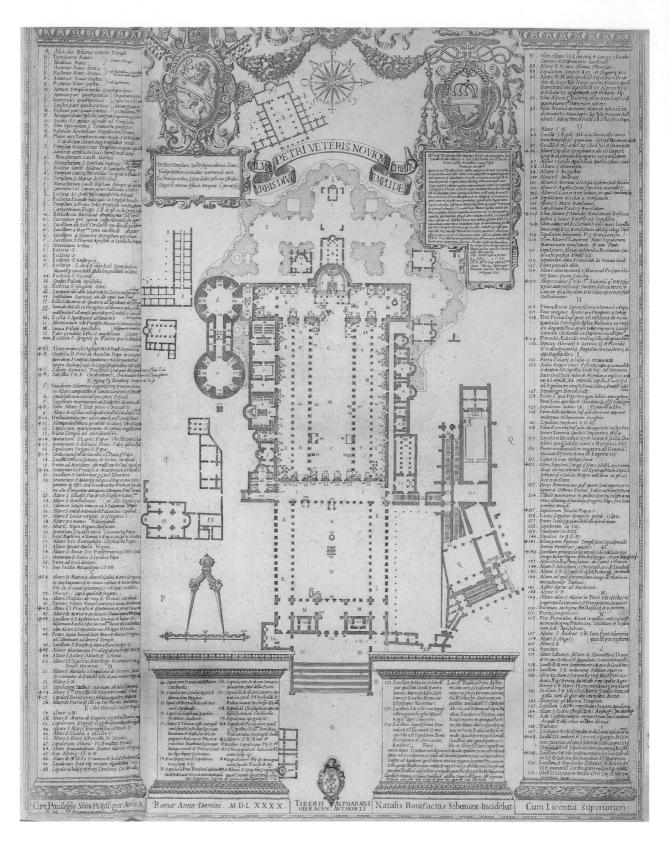

Engraved plan of the old St. Peter's Basilica (1589-90) by Tiberio Alfarano. The print provides most valuable documentation on the disposition of altars, tombs, cibaria and monuments which over the centuries adorned the mediaeval basilica. The outline of the new basilica is shown in a lighter tone of black. (Photo Biblioteca Apostolica Vaticana).

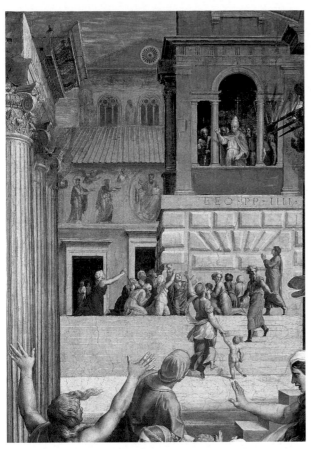

Detail of the fresco of the Incendio di Borgo (c. 1517) in the Raphael Stanza of the same name with the Pope imparting his blessing from the Loggia of the Benedictions. On the left in the background one can see the mosaic decoration on the façade of the old basilica.

Below. View of the façade and atrium of the old St. Peter's Basilica: the drawing by Domenico Tasselli (c. 1611) shows in the foreground the four-doored portico of the basilica, known as "Paradise" because of the splendour of its marble and decorations and, in the background, the mosaic decoration chosen by Gregory IV (827-844) and restored by Gregory IX (1237-1241). (Photo Biblioteca Apostolica Vaticana).

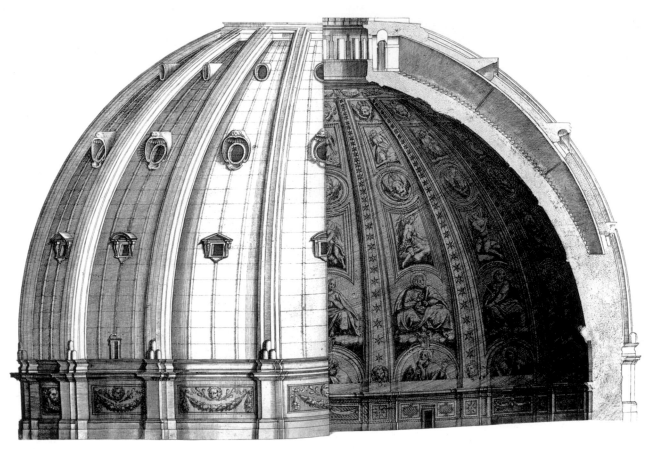

Michelangelo's cupola, completed by Giacomo della Porta in 1590, as it appears in an engraving by Martino Ferraboschi (1620) who depicts it with one half showing the external decoration and the other the internal. (Photo Archivio Fabbrica di San Pietro).

four pilasters and supporting arches of the cupola.

Various architects followed one another in directing the work after the death of Bramante, the first being Raphael Sanzio who, radically modifying Bramante's original plan, returned to the idea of a Latin Cross with a long longitudinal body with five naves.

This arrangement was continued in the plans presented by the architects who followed Raphael, among whom particular mention must be made of Antonio da Sangallo the Younger, summoned by Paul III (1534-49), and under whose impulse the work proceeded much faster.

An important event took place in 1547 when Michelangelo Buonarotti was appointed to oversee the work and who on the invitation of Pope Paul III returned to developing the idea of a basilica in the form of a Greek Cross and a great central cupola based on that of Santa Maria del Fiore in Florence.

His plan for the cupola unequivocally character-ized the panorama of the eternal city: the now

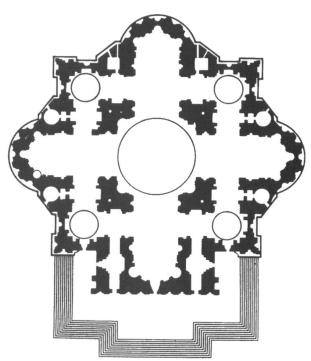

Plan of Bramante's design for the new St. Peter's Basilica.

22

famous "Cuppolone" (as the Romans call it) has become the symbol of Christian Rome. At the time of his death (1564) the work had reached the level of the tambour[6]. The completion of the work is due to two architects Giacomo Della Porta and Domenico Fontana who, under the strong urging of Sixtus V (1585-1590) completed the cupola in 1590, after only 22 months of work.

To the work of Carlo Maderno and the initiative of Paul V (1605-1621) are due the realization of the impressive façade (1612-1616) of the new St. Peter's Basilica and the return to the Latin Cross plan with the lengthening of the central nave.

Under Urban VIII (1623-1644), a good 1,300 years after the construction of the first basilica, the new Basilica of St. Peter's was solemnly consecrated on the 18th of November 1626.

The scenographic effect of the greatest basilica in Christendom, whose area covers about 25,000 sq. metres, was significantly amplified by the rearrangement of the square by Gian Lorenzo Bernini, who with the solution of the double elliptical colonnade (1656-1667) succeeded in symbolically rendering the maternal embrace of the Church towards her faithful.

The interior

"One cannot but venerate a religion capable of producing such beauty. Nothing in the world can be compared to the interior of St. Peter's. After a year's stay in Rome, I used to go there and spend entire hours with great pleasure." (Stendhal).

This was noted by the great French nineteenth century novelist during his long stay in Italy.

Entering St. Peter's, the greatest Christian basilica ever constructed, the first sensation is that of astonishment: the grandeur of the interior seems to overwhelm human "insignificance", but soon afterwards the immensity which surrounds him makes the individual feel he is part of a greater and more profound reality, entering into a dimension that is

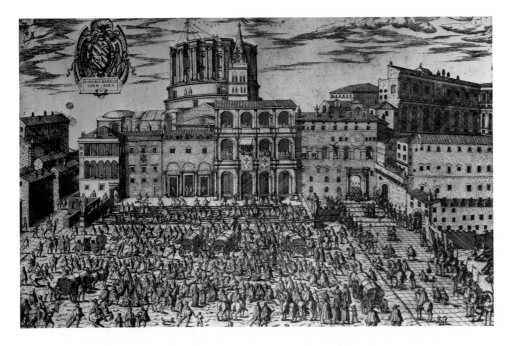

Engraving of c. 1575 depicting a benediction in St. Peter's Square. In the background one sees Michelangelo's dome which, ten years after the master's death, still appears to have stopped construction at the level of the tambour.

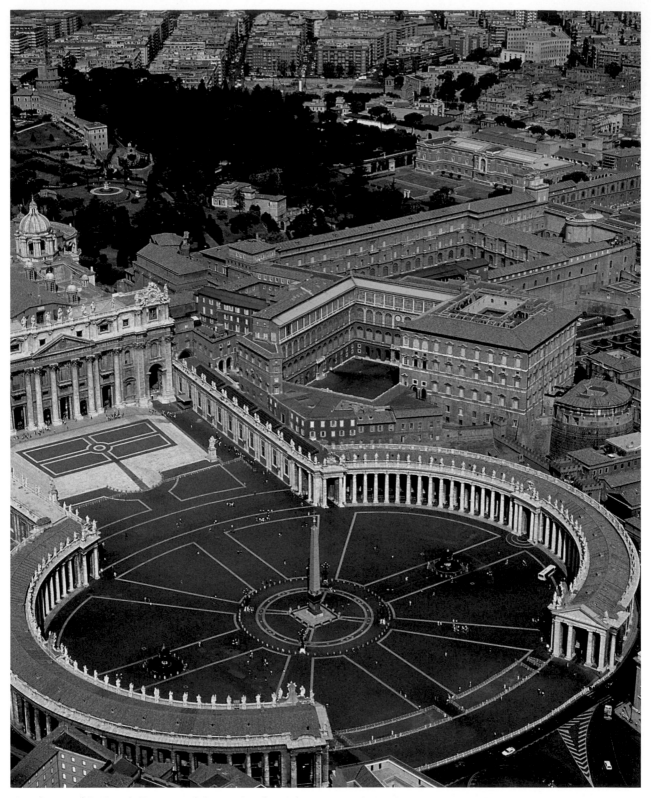

Aerial view of St. Peter's Square with Bernini's colonnade. (Photo Archivio Alinari).

Preceding page. *Top storey of the facade of St. Peter's. Christ giving His blessing flanked by St. John the Baptist (left) and St. Andrew (right). At the top of the façade of St. Peter's stands a series of thirteen statues with Christ in the centre surrounded by the Apostles. St. John the Baptist appears in the place of Judas Iscariot. (Photo Archivio Fabbrica di San Pietro in Vaticano).*

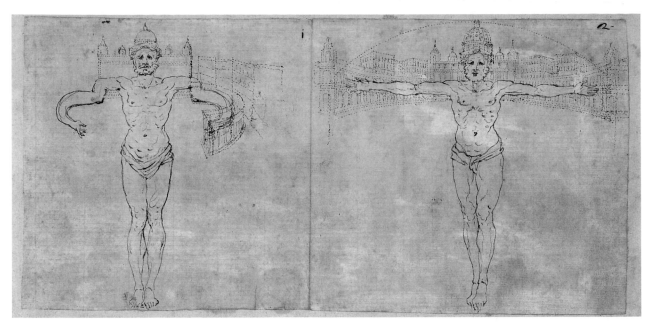

Drawing of St. Peter's Square made to symbolically resemble a human figure. This double ink drawing (17th century), conserved in the Vatican Apostolic Library and at one time held to be by the hand of Bernini, demonstrates how Gian Lorenzo Bernini in his realization of the colonnade of St. Peter's Square sought to give form to the "mother" Church's embrace of the faithful, her "children". (Photo Biblioteca Apostolica Vaticana).

totally different, one of pure contemplation of the divine mystery.

The heart of the basilica is St. Peter's tomb: the altar which rises above it has been magnificently exalted by the creative power of Bernini who expressly erected an impressive bronze baldacchino (1633) to restore the proper centrality to St. Peter's chapel which otherwise ran the risk of remaining in second place, lost in the vastness of the central nave. For the realization of the grandiose structure in bronze with columns spiralling upwards (29 metres), Pope Urban VIII Barberini (1623-1644), the patron of the enterprise, had to use a tenth of the Church's income and melt down the bronze girders of the portico of the Pantheon. This prompted the saying "what the barbarians did not do the Barberinis did"!

Progressing along the central nave and looking towards the sides one immediately notices the statues of the founders of Religious Orders, the altars and funerary monuments of various pontiffs in a sumptuous gallery of decorative elements that fully fits in with the elaborate baroque taste of the interior.

The baroque stamp is due, above all, to the hand of Bernini, who besides the baldacchino, also produced the masterful bronze cathedra (1666) of the apse, planned to preserve the relic that tradition claimed to be the chair from which St. Peter preached to the Christians of Rome during his final years[7]. Bernini's cathedra powerfully dominates the sacred area of the basilica: right from the entrance, clearly visible through the columns of the baldacchino, are the sparkling hosts of angels, who between dazzling rays of light and billowing clouds, surround the dove of the Holy Ghost, the precious and only centre of radiation that inundates with light all that it reaches. At the base of the bronze cathedra are represented the four Doctors of the Church, St. Ambrose and St. Augustine of the Latin Church, St. Athanasius and St. John Chrysostom of the Greek Church.

To the right of the altar is the *Monument to Urban VIII* (1647) this too a splendid bronze by Bernini who has portrayed the Pope, his mentor and patron, in the act of imparting the solemn benediction from the throne on which he is seated robed in

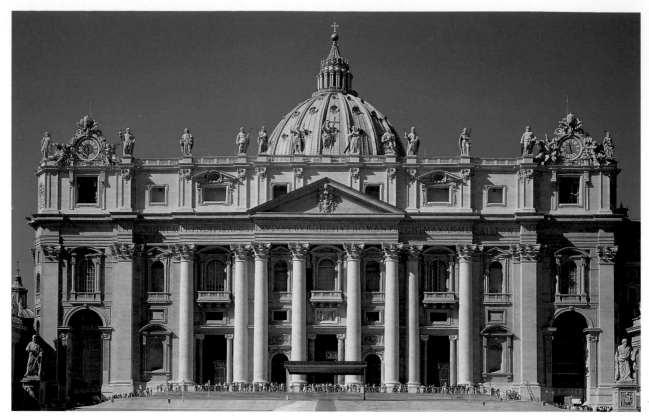

St. Peter's Basilica. The impressive façade of the basilica, realized by Carlo Maderno during the pontificate of Paul V (1605-1621), consists of a single order of gigantic columns and pilaster strips upon which rests a great cornice crowned by thirteen statues, the central point being the statue of the Redeemer. (Photo Archivio Fabbrica di San Pietro in Vaticano).

his pontifical vestments and bearing the triple tiara on his head. On the sides of the base are the female figures of Charity and Justice.

It is also to Bernini that we owe the placing in niches almost ten metres high carved out of the pilasters that support the central dome, of four imposing statues (1629-1640) depicting St. Longinus, the work of Bernini himself, St. Helena by Andrea Bolgi, the Veronica by Francesco Mochi, and St. Andrew by Francesco Duquesnoy.

Under the pilaster of St. Longinus is the splendid bronze statue of *St. Peter Enthroned*, attributed by the most authoritative scholars to Arnolfo di Cambio (1245-1302), surrounded by deep veneration from medieval times as can be seen from the right foot which has by now been almost worn away by the kisses of the millions of faithful who still today repeat the ancient devotional gesture. On the occasion of the feast of St. Peter, the 29th of June, the statue is clothed with sacred vest-

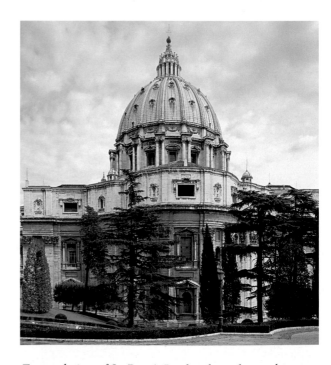

External view of St. Peter's Basilica from the north-west.

28

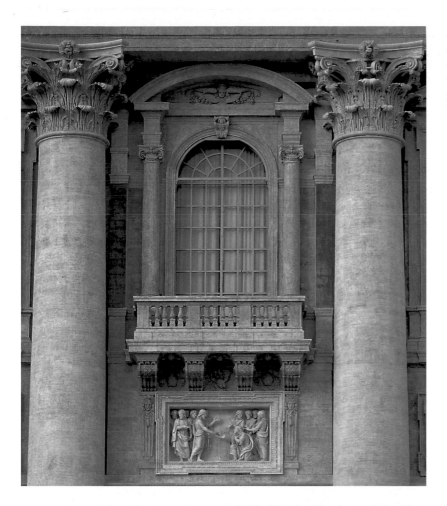

Façade of St. Peter's Basilica. Detail of the Loggia of the Benedictions and of the marble high-relief by Buonvicino (1552-1622) depicting "Christ giving the keys of the Church to Peter". (Photo Archivio Fabbrica di San Pietro in Vaticano)

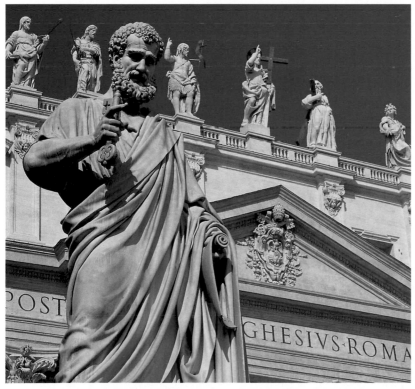

St. Peter's Basilica. The statue of St. Peter by the Venetian sculptor G. De Fabris (1790-1860) on the consecrated ground in front of the basilica. (Photo Archivio Fabbrica di San Pietro in Vaticano).

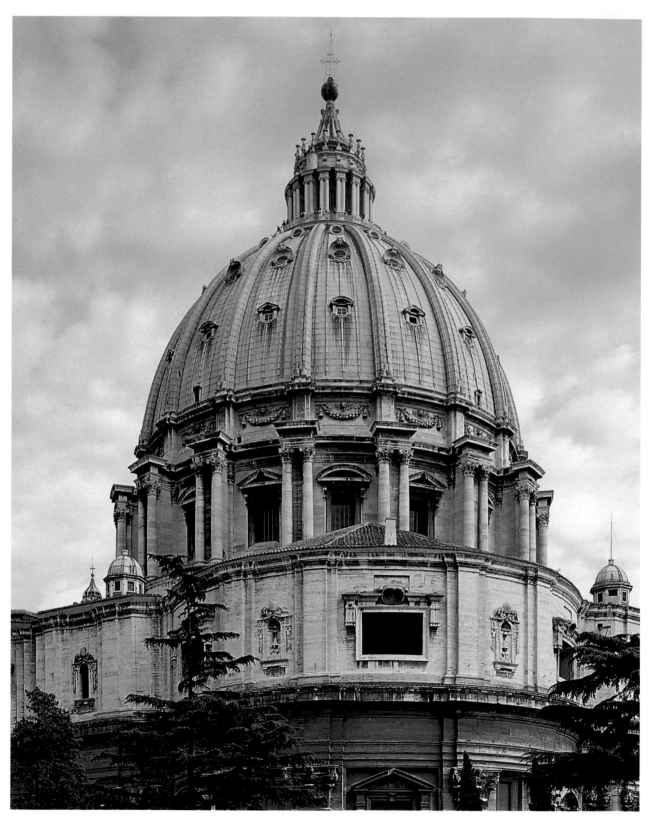

The dome of St. Peter's seen from the exterior. The imposing structure (140 m. high and 42 m. in diameter) rests on a lofty tambour with twin columns alternated by windows above which develops a cornice with festoons and lion heads, which in turn provides the base for the ribbed dome. At its tip the lantern with columns is surmounted by a great sphere of gilded bronze upon which a cross rests.

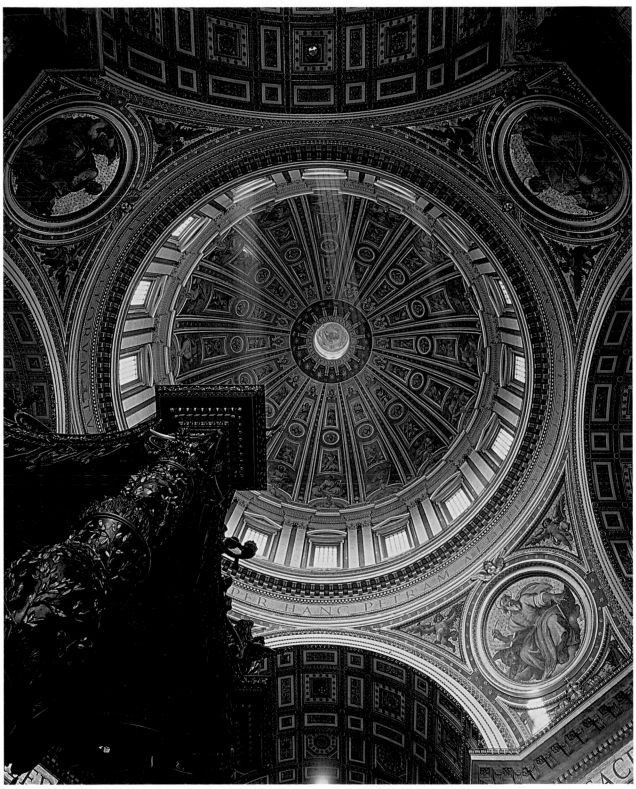

Interior view of the dome of St. Peter's. Decorated in mosaic, it is subdivided into sixteen segments which converge towards the summit of the lantern from which the figure of the Eternal Father is imparting His blessing. In the circular fillet at the base of the tambour the words from St. Matthew's Gospel (16, 18-19) are reproduced in mosaic: Tu es Petrus et super hanc petram aedificabo ecclesiam meam. Tibi dabo claves regni caelorum *("Thou art Peter and upon this rock I will build my Church. And I will give unto thee the keys of the Kingdom of Heaven") that mark Peter's investiture to the guidance of the Church. (Photo Archivio Fabbrica di San Pietro in Vaticano).*

ments and crowned with the triple crown, the tiara symbolic of the Pope's three-fold power (father of kings, ruler of the world, vicar of Christ).

Moving towards the entrance, half way down the right nave, one comes to the Chapel of the Most Blessed Sacrament, enclosed by a refined iron gate in baroque style.

On the main altar the precious ciborium in gilded bronze (1674) is also a work by Bernini, who was certainly inspired by Bramante's tempietto at S. Pietro in Montorio.

Continuing always in the direction of the entrance we reach the first chapel of the right nave which contains one of the most admired masterpieces of Christian art, the *Pietà* (1498) by Michelangelo. This splendid marble group, sculpted by the maestro when he was only twenty-four years old, is now protected by bullet-proof glass since 1972, when a madman struck it with a hammer several times, damaging some parts, which were quickly and effectively restored by the Vatican Museums Restoration Laboratory.

Of the only signed work by Michelangelo, on the sash of the Blessed Virgin, Vasari wrote: "... it would be impossible to find a body showing greater mastery of art and possessing more beautiful members, or a nude with more detail in the muscles, veins and nerves stretched over their framework of bones, or a more deathly corpse. The lovely expression of the head, the harmony in the joints and attachments of the arms, legs and trunk, and the fine tracery of pulses and veins are all so wonderful that it staggers belief that the hand of an artist could have executed this inspired and admirable work so perfectly and in so short a time. It is certainly a miracle that a formless block of stone could ever have been reduced to a perfection that nature is scarcely able to create in the flesh. Michelangelo put into this work so much love and effort that (something he never did again)

he left his name written across the sash on Our Lady's breast..." (Vasari, *Lives of the Artists*).

But we now come to the heart of the basilica: the *Confessione*[8] or the area that surrounds the tomb of the Apostle to whom are dedicated the words inscribed in the circular fascia at the base of the dome, the superb crowning of the sacred chapel: *Tu es Petrus et super hanc petram aedificabo ecclesiam meam et tibi dabo claves regni caelorum*) ("Thou art Peter and upon this rock I will build my Church and I will give unto thee the keys of the Kingdom of Heaven", Mt. 16, 18-19).

The consecrated area, the goal of countless pilgrims who from the end of the 1st century A.D. coming from every corner of the world have braved interminable journeys per *videre Petrum* (to see Peter), is surrounded by a rich balustrade and two semi-circular flights of stairs on which 89 oil lamps burn day and night, the symbol of inextinguishable faith. At one time at the bottom of this double flight of stairs there was the statue of Pius VI (1775-1799), the last of Antonio Canova's works (1822) and which is now preserved in the Vatican crypt. The statue, of which Canova provided the model and sculpted only the head and the hands (the remainder was completed by his pupil Adamo Tadolini), depicts the Pontiff, who died in exile in Valence, in an attitude of moving prayer. Descending the double staircase there is the so-called *Niche of the Pallia*. Inside is a precious bronze urn containing the pails, stoles woven from the wool of the lambs blessed on the feast of St. Agnes (21st February), in the Roman church of the same name, which the Pope gives to metropolitan archbishops as a sign of their vocation as "pastors" of the Christian people. At the back of the niche, there is the mosaic of Christ Pantocrator (from the Greek "Omnipotent"), that can be dated to the 9th century A.D.

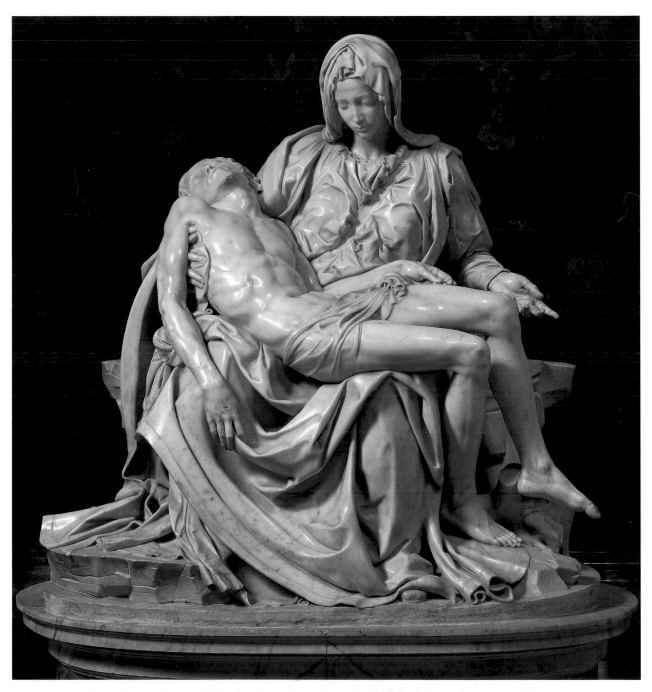

The Pietà. The sculpture is an early work by Michelangelo, commissioned when he was only 24 by the French Cardinal Jean Bilhères de Lagraulas for the chapel of St. Petronilla, where it remained until the demolition of the church in 1544. The theme of the Pietà was particularly congenial to Michelangelo's spirit: in fact he sculpted four works with this subject, of which this was the first and only one to be completed. (Photo Archivio Fabbrica di San Pietro in Vaticano).

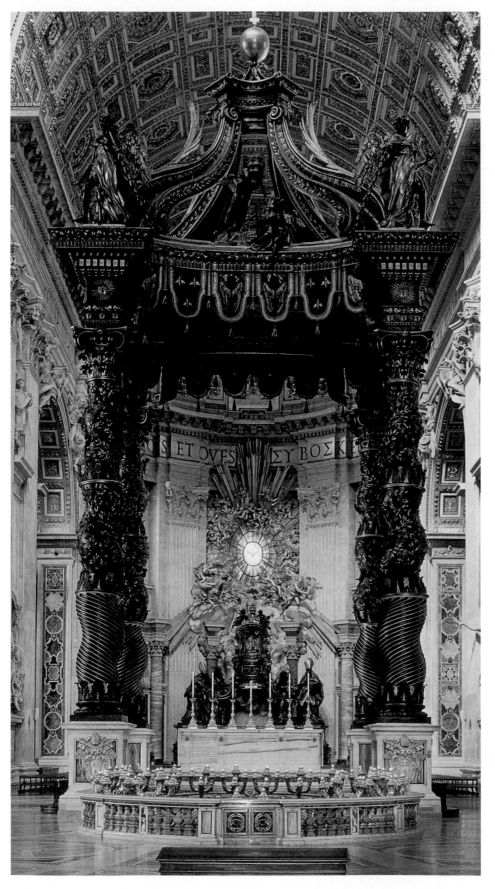

Bronze Baldacchino and
Cathedra of Bernini.
Inaugurated by Urban VIII
on the 29th June 1633, the
impressive baldacchino of
gilded bronze, masterpiece
of Baroque taste about 29
metres in height, acts as
the majestic crowning of
the papal altar at the cen-
tre of Michelangelo's cen-
tral crossing. In the back-
ground, beyond the
baldacchino Bernini's
other great work is clearly
visible: the altar of the
Cathedra (1657-1666),
a magnificent and
scenographic bronze
monument erected with
the aim of exalting the
primacy of Peter.
(Photo Archivio Fabbrica di
San Pietro in Vaticano).

Above, right.
Bronze statue of St. Peter
imparting his blessing. This
ancient statue is considered
by some scholars to be the
work of Arnolfo di Cambio
(1245-1302), by others an
anonymous work of the
5th century.
(Photo Archivio Fabbrica di
San Pietro in Vaticano).

THE SACRED GROTTOES

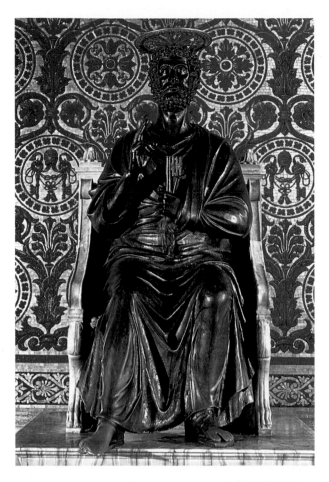

With one's back to the Confession, let us now go towards the pillar of St. Longinus. From here we can go down a narrow staircase to a vast subterranean area known as the *Vatican Grottoes*. This large area, realized between the pontificates of Gregory XIII (1572-1585) and Clement VIII (1592-1605) owes its origin to the period in which the new Basilica of St. Peter's was built: the floor of the new basilica was in fact raised about two metres higher than that of the Constantinian basilica and the resulting interstice between the two churches became a useful space to house the funerary monuments, sculptures and mosaics of the old basilica.

The vast subterranean area is made up of two main parts: one having three naves with a cross-shaped vault (*The Old Grottoes*) where the funerary monuments of many pontiffs were arranged and a semi-circular area that extends around the tomb of Peter (*The New Grottoes*) from which many side chapels radiate.

The central nucleus of the Sacred Grottoes is the *Clementine Chapel*, a splendid extension desired by Clement VIII of Gregory the Great's (590-604) semi-annular ancient crypt, from which it is possible to discern part of the *Monument* erected by Constantine over the tomb of the Apostle.

Beneath the Vatican Grottoes is the *Pre-Constantinian Necropolis* (2nd-3rd centuries A.D.) which lies which can be visited by making a written request to the Ufficio Scavi.

Left. *The Niche of the Pallia. In this niche, inside a bronze urn, are kept the palliums, that is to say the stoles of white wool that the Pope consigns to metropolitan bishops as a reminder of their sacred mission.*
(Photo Archivio Fabbrica di San Pietro in Vaticano).

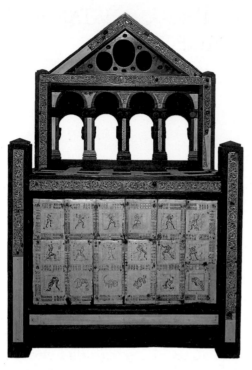

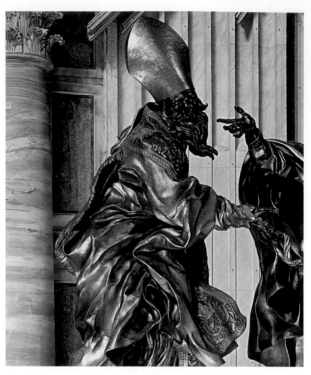

The wooden Cathedra, according to tradition the throne from which St. Peter preached, is in reality a gift from Charles the Bald to the Pontiff on the occasion of his imperial coronation (875). (Photo Archivio Fabbrica di San Pietro in Vaticano).

St. Ambrose, detail of one of the four impressive statues depicting the Doctors of the Western and Eastern Churches at the base of Bernini's Cathedra. (Photo Archivio Fabbrica di San Pietro in Vaticano).

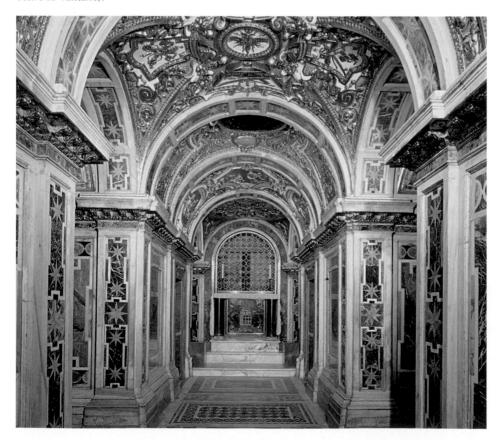

Clementine Chapel. Behind the altar can be seen, through a grating the back of the funerary monument built by Constantine in honour of the Apostle Peter. (Photo Archivio Fabbrica di San Pietro in Vaticano).

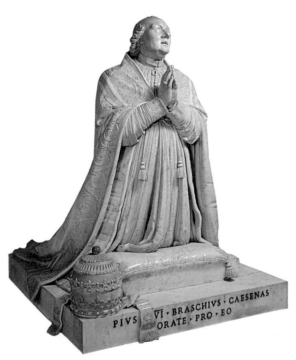

Monument of Urban VIII. For his protector, Gian Lorenzo Bernini realized this majestic funerary monument (1647) which represents the Pontiff in the act of imparting his blessing. (Photo Archivio Fabbrica di San Pietro in Vaticano).

Statue of Pius VI. Begun by Canova and completed by Tadolini (1822), the statue stands today at the end of the central nave of the Grottoes. The base bears the inscription in Latin: "Pius VI Braschi, of Cesena. Pray for him". (Photo Archivio Fabbrica di San Pietro in Vaticano).

THE PRE-CONSTANTINIAN NECROPOLIS

As we have already said, the Constantinian basilica was built over the spot where the Apostle Peter was martyred, between 64 and 67 A.D., in the circus of Caligula and Nero. His body was laid in a simple rock tomb carved out of the burial place near the site of his martyrdom. And it is around this simple tomb that there grew up a vast necropolis made up of both pagan and Christian burials.

The rediscovery of the necropolis is due in great part to the excavations conducted under Pius XII between 1940 and 1951. A double row of sepulchral structures, called *mausoleums* and identified by archeologists with letters of the alphabet, was found. Among those that are worthy of special mention is *Mausoleum A* or of *Popilius Heracla*, in the inscription of which the owner states his wish to be buried *In Vaticano ad circum* ("in the Vatican, close to the circus").

The most important part of the necropolis is the area which contained the body of Peter, called *Field P*, which lies to the west and is composed of many other burials dating back to the 1st and 2nd centuries A.D. alongside that of the Apostle.

Already in the 2nd century A.D. Peter's tomb was distinguished from the others being surmounted by a *Trophy* or *Aedicula*, a niche flanked by two small columns, set very near to the so-called *Red Wall*[9], erected to fix the boundaries of Field P on the west. In the 3rd century perpendicular to the red wall the so-called *Wall G*, or of the *Graffiti*, was built. This is of fundamental archaeological interest because in it the scholar Margherita Guarducci identified the small cavity into which the remains of St. Peter were translated from the original tomb under the Red Wall to save them from possible profanation. In the 4th century, Constantine, who made the tomb of the Apostle the axis of the entire basilica built in his honour, surrounded the small tabernacle-like monument with an elegant bronze baldacchino supported by four spiraling columns from which a sumptuous chandelier hung.

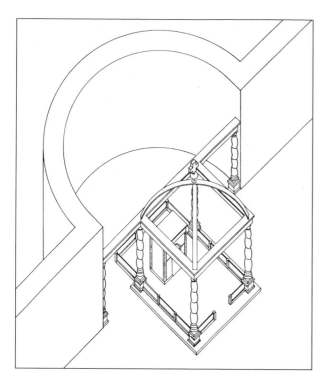

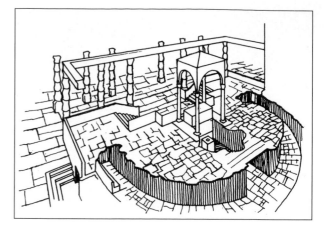

Above. *The semi-annular crypt of Gregory the Great. Towards the end of the 6th century, the pavement of the apse was raised by about a metre and a half and a semi-circular corridor was carved out from which one reached a chapel attached to the Constantinian Trophy.*

Reconstruction of the Constantinian monument: a baldacchino in bronze with serpentine marble colums which were to inspire, about one thousand three hundred years later, Bernini in the realization of the baldacchino that still today dominates the area above the altar.

Right. *Axonometrical plan of the so-called "Field P". Clearly visible the Aedicula on the tomb of Peter leaning against the Red Wall just as it must have appeared already at the end of the 2nd century.*

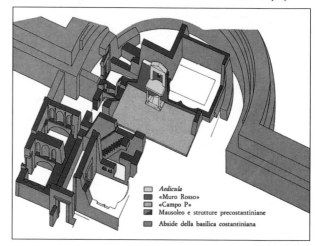

Aedicula
«Muro Rosso»
«Campo P»
Mausoleo e strutture precostantiniane
Abside della basilica costantiniana

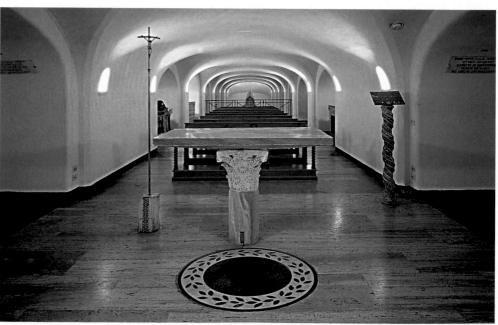

Overall view of the central nave of the Vatican Grottoes. (Photo Archivio Fabbrica di San Pietro in Vaticano).

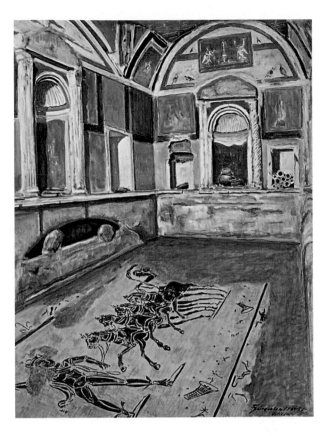

View of the interior of Mausoleum I or "of the chariot" (1951-53). The painting by F. Jurgensons is part of a series of ten illustrating various subjects of the Vatican necropolis, donated by Paul VI to the Fabbrica di San Pietro in 1977. (Photo Archivio Fabbrica di San Pietro in Vaticano).

Below. *View of the interior of Mausoleum F or "of C. Caetennius Antigonus" (1957-58). In this case too Jurgenson's painting faithfully reproduces the interior of the first mausoleum escavated in the course of the work carried out in the area beneath St. Peter's Basilica between 1940 and 1951. (Photo Archivio Fabbrica di San Pietro in Vaticano).*

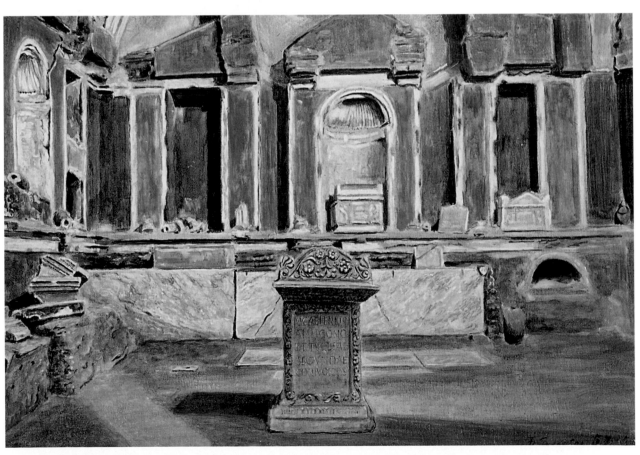

THE SACRISTY AND TREASURY OF ST. PETER'S

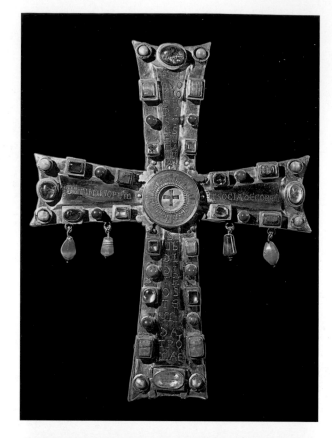

Completing the tour it is possible to visit the Sacristy, a large building to the south of the basilica, planned and completed by Carlo Marchionni in 1784 and the Museum-Treasury of St. Peter's, arranged in several rooms adjacent to the Sacristy of the Incumbents on the first floor of the building.

The Museum contains the most important sacred vestments and articles of worship, which escaped pillaging down through the years and which were donated in the course of centuries to the Vatican basilica by emperors, kings, princes and other important personages.

Among the most ancient and precious relics we must point out the *Cross of Justin II* and the so-called *Dalmatic of Charlemagne*, said to have been a gift from the founder of the Holy Roman Empire (800), but which in fact is a Byzantine masterpiece of the 11th century.

Rooms IV and IX are dedicated to two works of great artistic interest: in Room IV there is the *funerary monument of Sixtus IV*, a precious work in bronze by Antonio Pollaiolo, signed and dated by the maestro (1493), while in Room IX there is the *Sarcophagus* of *Junius Bassus* (c. 359), one of the most important examples of Christian art of the first centuries.

Above. *Museum of the Treasury of St. Peter's. Cross of Justin II (6th century). (Photo Capitolo di S. Pietro).*

Below. *Museum of the Treasury of St. Peter's. The dalmatic, known as that of Charlemagne (c. 11th century). (Photo Capitolo di S. Pietro).*

Following page, above. *Museum of the Treasury of St. Peter's. Sarcophagus of Junius Bassus. Discovered in 1595 during the work for the construction of the new Basilica of St. Peter, the precious find in Parian marble, executed for Junius Bassus, a Roman prefect who died in 359 at the age of only 42, is decorated with scenes taken from the Old and New Testaments. (Photo Capitolo di S. Pietro).*

Following page, below. *Museum of the Treasury of St. Peter's. Antonio Pollaiolo. Funerary monument of Sixtus IV (1493). (Photo Capitolo di S. Pietro).*

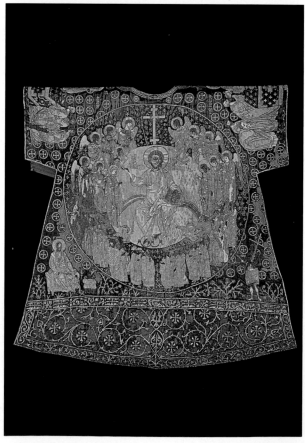

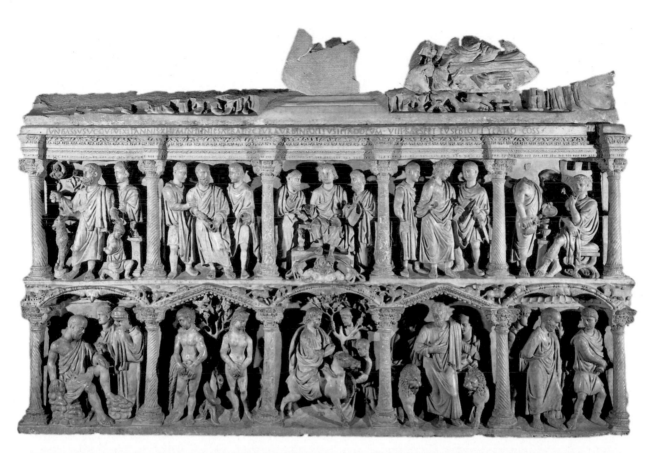

THE APOSTOLIC PALACES

The common thread of this chapter is the history of the Popes who down through the centuries have given life to, enlarged and embellished with splendid works of art the complex of the Apostolic Palaces to the north of the basilica, where the Pontiff still lives and works today. We have therefore chosen to follow a chronological route also in describing the works of art contained in them (the Sistine Chapel, for example) to emphasise the substantial unity that binds the various amplifications that took place down through the centuries.

Differently from what one might be tempted to believe, the Vatican was not the first residence chosen by the Popes, who lived instead in the Lateran for about a thousand years before moving to near the burial place of Peter.

Temporary simple lodging places were prepared to face eventual unforeseen emergencies: this was the case of Pope Simmachus (498-514) who, forced to leave the Lateran because of the presence of the anti-Pope Lawrence, had two *episcopia* built in the Vatican at the sides of the church, one. for himself and the other for his clergy.

At the same time a small village began to spring up around the basilica of the Apostle and this developed in an area that had no defences and was somewhat distant from the heart of the city on the other side of the Tiber.

In the IXth century, following the profanation and the sacking of the tomb of Peter and the surrounding village by the Saracens (846), Pope Leo IV (847-855) decided to fortify the whole Vatican complex, surrounding it with mighty walls. This was the start of the *Civitas Leonina* (the Leonine City).

The first Pope who came to reside permanently in the Vatican was Nicholas III Orsini, (1277-1280). To him is due the construction of the original nucleus of the Apostolic Palace, which was built around the present Cortile del Pappagallo. Besides drawing up plans for a fortified residence with angular towers, Pope Nicholas III is generally considered to have

Southern prospect of the Palace of Sixtus V. Erected by Sixtus V Peretti (1585-90) to house more practical papal apartments (a function it still fulfils), the massive construction on a square plan, work of the architect Domenico fontana, looks to the west over the Cortile di S. Damaso from which it takes up again the decoration of superimposed loggias. To Domenico Fontana are also due the other great undertakings carried out under Sixtus V's pontificate: the construction of the new Apostolic Library building, the removal of the obelisk to the centre of St. Peter's Square and the completion of Michelangelo's dome for St. Peter's Basilica, (cf. p. 90 et seq.).

The Cortile del Pappagallo looking towards the Cortile Borgia.

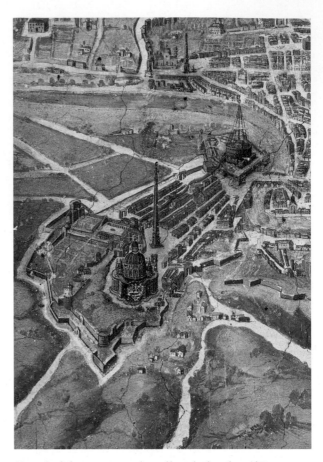

Detail of the ornamental scroll with the plan of Rome from the geographical map Latium et Sabina in the Galleria delle Carte Geografiche (end of XVIth c.) of the Vatican Museums. In the foreground, the Vatican complex with its mighty surrounding wall. In the background, Castel S. Angelo, formerly the Mausoleum of Hadrian, stands out.

Right. *Castle keep of Nicholas V (1447-1455). The edifice on a circular plan erected by Pope Parentucelli about 1450 for defensive purposes and which has come down to us almost unaltered, is today the headquarters of the Istituto per le Opere di Religione (IOR).*

Following page. *Above, left. Perspective view of the Cortile della Sentinella (end of XVIth c.) and of the Cortile Borgia (end of XVth c.) from the Piazza del Forno.*

Following page. *Above, right. Detail of the southern prospect of the Cortile del Belvedere with the Borgia Tower on the right.*

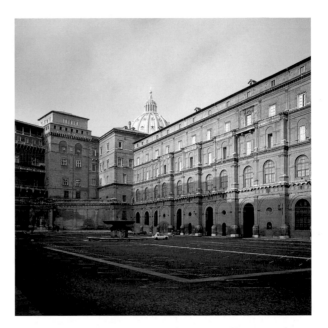

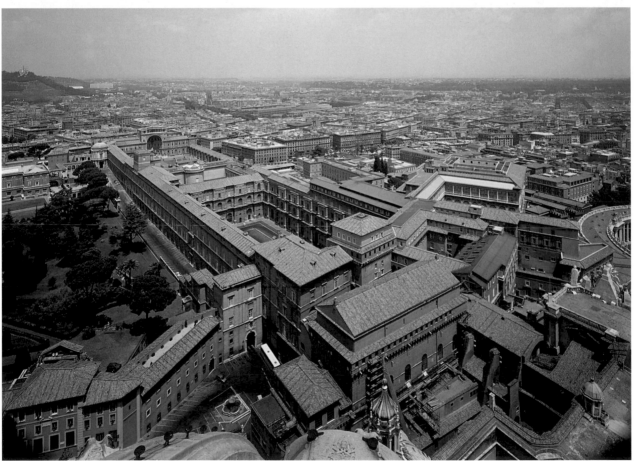

View of the Apostolic Palaces from the dome of St. Peter's. Below toward the right one notices the Sistine Chapel, to its right the area of the Cortile del Pappagallo where the first nucleus of the Palaces developed. Immediately beyond one has a glimpse of the upper part of the façade of the Palace of Sixtus V which looks out on the Cortile di S. Damaso, of which it constitutes the eastern prospect. Clearly visible also the succession of the three Cortiles (del Belvedere, della Biblioteca and della Pigna) which link the Apostolic Palaces to the south with the Palazzetto of Innocent VIII to the north.

been responsible for the first Palatine Chapel (demolished, it seems, in the XVth century to make room for the Sistine) (10) with the extension of the walled boundary to the north Nicholas III is also considered the founder of the first Vatican Gardens.

The turbulent historical events that marked the XIVth century (11) caused an inevitable break in the building process, which restarted only in the XVth century with the ascent to the pontifical throne of the great humanist Nicholas V, of the Parentucelli family (1447-1455). To this enterprising Pope, whose two passions "for books and buildings" are well known, is due the drawing up of a wide-ranging and ambi tious renewal plan for the Vatican area. Firstly he began with the construction of a second fortified enclosure, realized only in part, of which today is still visible the impressive Tower close to the Porta S. Anna. He completed the north wing of Nicholas III's palace (the part looking out on the Cortile del Belvedere), returning to the external prospect the prototype of a fortified fourteenth century palace while allowing the most profound spirit of the renaissance to penetrate inside, as is testified by the splendid decorations of the artists who worked for him, above all those of the Dominican fra Giovanni da Fiesole, better known as Fra Angelico (1395-1455) the author of the famous Cappella Niccolina - the Chapel of Nicholas V (1447-1450). The second and probably the third floors of Innocent III's tower (1198-1216), which forms part of the most ancient nucleus of the Pontifical Palace, were used for the chapel, which was incorporated at the end of the thirteenth century into the wing built by Nicholas III.

THE NICCOLINE CHAPEL

The private chapel of the Parentucelli Pope, the small rectangular area is frescoed with the figures of the four evangelists against the background of a star-studded sky on the cross-shaped ceiling, with figures of the Doctors of the Church on the corner pilaster strips (12) and with scenes taken from the life of St. Stephen (upper register) and of St. Lawrence (lower register) on the walls. The base which has been returned to its original appearance after the latest restoration, represents mock curtains with Nicholas V's coat of arms in the centre.

The episodes depicted on the walls are set in wide architectural spaces, learnedly constructed in accordance with fifteenth century perspective canons, that act as a splendid background for the account of the most outstanding moments in the lives of thc two martyrs.

The cycle dedicated to St. Stephen is developed in the upper part of the walls and starts on the wall to the right as one enters. The first scene represents *St. Peter conferring the diaconate on St. Stephen* and *St. Stephen distributing alms to the poor*; the cycle continues on the entrance wall with the *Preaching of St. Stephen* and the *Dispute in the Sanhedrin* and concludes on the left wall with *St. Stephen being led to his execution* and with the *Stoning of St. Stephen*.

On the lower register of the walls, following the same development as the one above, the cycle dedicated to St. Lawrence continues with the desired parallelism. It starts with the representation of *St. Sixtus conferring the diaconate on St. Lawrence*, continues with *St. Sixtus distributing the treasures of the Church to St. Lawrence* and *St. Lawrence giving alms*, and concludes with *St. Lawrence appearing before the tribunal of the Emperor Decius* and with the *Martyrdom of St. Lawrence* (the latter completely re-arranged in the XVIth century following the opening of the small window that enabled those in the adjoining Sala degli Svizzeri to follow Mass).

"In various of these compositions the influence of antiquity is absolutely undeniable... Like his protector and friend, the Pope, Fra Angelico knew how to unite veneration of antiquity with even the most sincere love of Christianity... Christian thought remained intact in his Vatican frescoes and it was

Fra Angelico. Ceiling of the Niccoline Chapel with the four Evangelists and their respective symbols portrayed on the background of a star-studded sky. One distinguishes, clockwise, St. Matthew and the angel, St. John and the eagle, St. Luke and the bull, St. Mark and the lion.

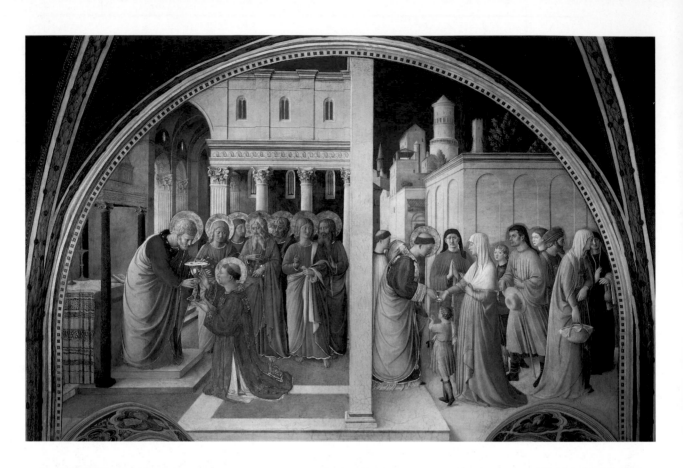

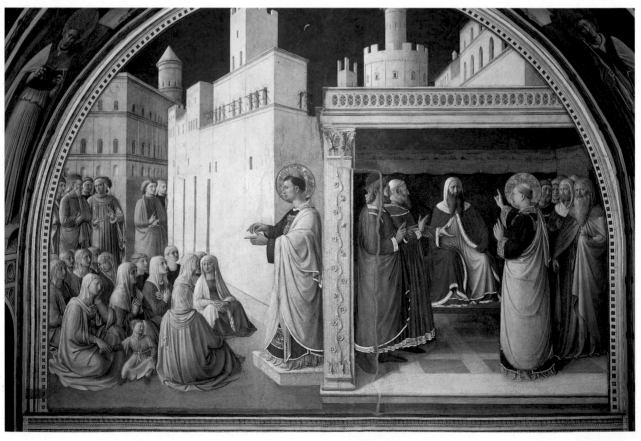

Preceding page, above. *Fra Angelico. West wall of the Niccoline Chapel. St. Peter who is conferring the diaconale on St. Stephen and St. Stephen who is distributing alms.*

Preceding page, below. *Fra Angelico. Entrance wall of the Niccoline Chapel. St. Stephen preaching to the people and the Dispute in the sanhedrin.*

Left. *Fra Angelico. Arch of the altar of the Niccoline Chapel. St. Gregory the Great.*

Below. *Fra Angelico. East wall of the Niccoline Chapel. St. Stephen being taken to his death and the Stoning of St. Stephen.*

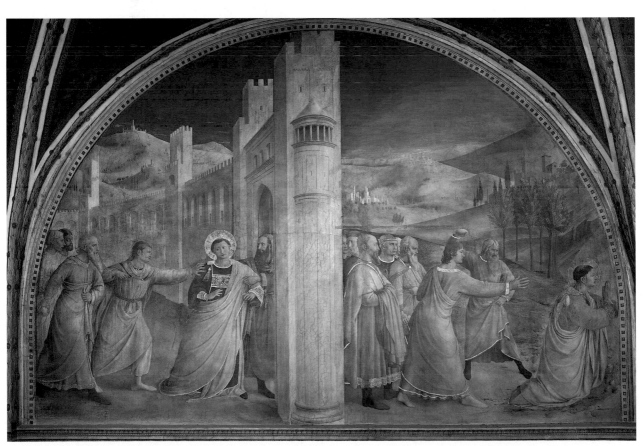

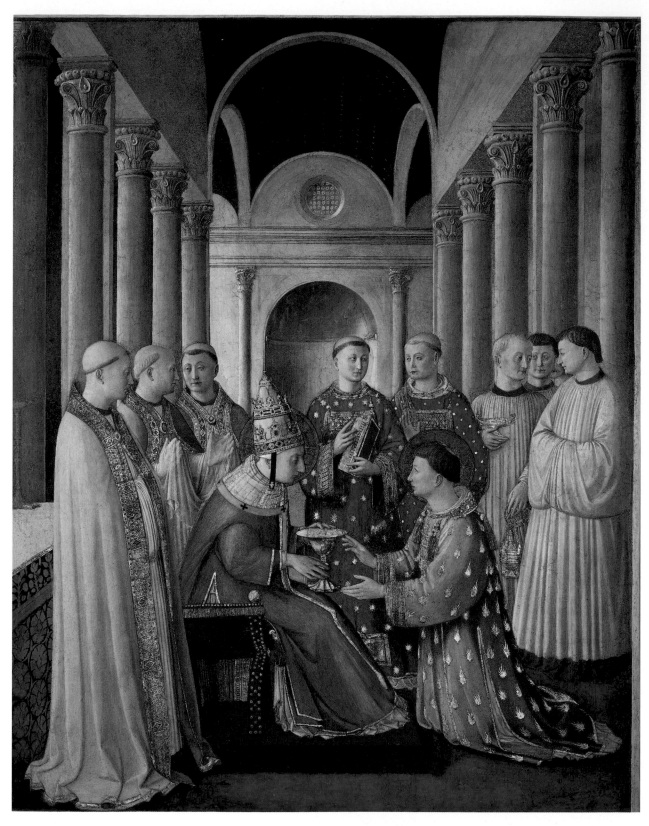

Fra Angelico. West wall of the Niccoline Chapel. St. Sixtus confers the diaconate on St. Lawrence. The scene of the diaconal consecration takes place against the background of a solemn and majestic Christian basilica. Especially in the measured and elegant architecture of the background, the Angelico succeeds in capturing with great expressive sensitivity the sense of continuity between imperial and papal Rome.

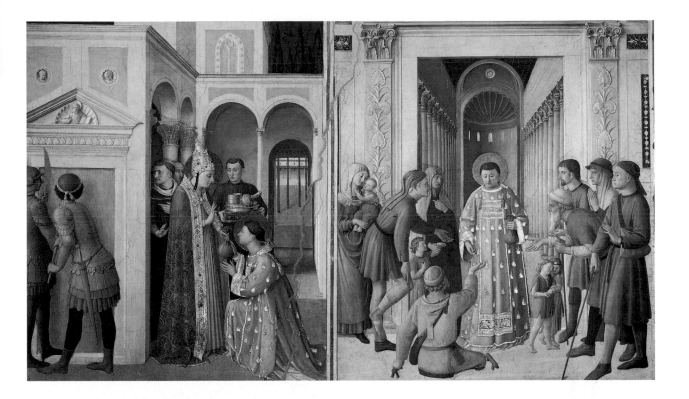

Above. *Fra Angelico. Entrance wall of the Niccoline Chapel. St. Sixtus entrusts the Church's treasures to St. Lawrence and St. Lawrence gives alms.*

Left. *Fra Angelico. Entrance arch of the Niccoline Chapel. St. Thomas Aquinas.*

even expressed in the most beautiful perfection" (Pastor, *Storia dei Papi*).

Nicholas V is also connected with the first plan for the reconstruction of St. Peter's Basilica, which by then had already been somewhat ravaged by time, as well as with the idea of creating a great library. The collection of about 1,500 splendid manuscripts (807 Latin and 353 Greek) that he left on his death constituted the first precious nucleus of the present Vatican collection.

A worthy heir and continuator of the two passions of Nicholas V ("books" and "building") was Pope Sixtus IV Della Rovere (1471-1484). His name is indissolubly linked with the Palatine Chapel (called the *Sistine* in his honour) which he had built on the site of Nicholas III's *capella magna* (cf. note 10) and the walls of which he had frescoed by the greatest artists of the time.

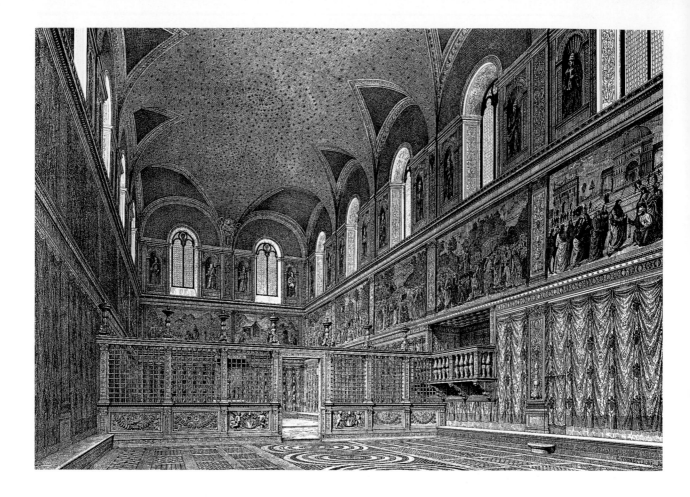

THE SISTINE CHAPEL. THE QUATTROCENTISTS

The Sistine Chapel, perhaps the most famous and most visited building in the Vatican Palaces, has a very simple structure: it consists of a rectangular hall of impressive dimensions (40.23 x 13.41 m.), the same measurements as those attributed to Solomon's Temple by the Bible, with a polycentric vault with lunettes corresponding to the 12 windows. The reconstruction work, conducted by Giovannino de' Dolci following the plan of Baccio Pontelli, commenced about 1477 and was finished in 1483, when the wall frescoes were also completed. The fresco decoration is articulated on three registers: the lowest representing mock tapestries, the central register develops the incidents of Christ's life on one side and those of Moses on the other, while the upper registers: between the windows, depicts the histories of the first pontiffs, painted in their entirety inside false marble niches. At the time of the consecration of the chapel in 1483, the ceiling depicted a star-studded sky, the work of Pier Matteo d'Amelia, which was replaced at the beginning of the sixteenth century by Michelangelo's frescoes.

The pictorial cycle worthy of the greatest interest is certainly the central one with stories from the Old and New Testaments; it starts from the wall behind the altar, where today there is Michelangelo's Last Judgement and concludes on the entrance wall where, because of structural subsidence, the two original episodes, The *Resurrection of Christ* by Ghirlandaio and the *Dispute over the body of Moses* by Luca Signorelli, were repainted in the late sixteenth century by Hendrick van den Broeck and Matteo da Lecce respectively.

The series of frescoes was completed in a very short time "thanks to the close collaboration that united the artists and their various workshops in a team-work that is rarely to be found in the painting of any time" (from *La Cappella Sistina*, text by Francesco Mancinelli, Edizioni Musei Vaticani, p. 5). An important document that is preserved in the

Vatican Secret Archives, which bears the date of the 27th of October 1481, lists the names of the artists who were summoned for the work by Pope Sixtus IV: Cosimo Rosselli, Sandro Botticelli, Domenico Ghirlandaio and Pietro Perugino. To the four artists who worked with their various workshops under the supervision of Giovannino de' Dolci, towards the end must be added the name of Luca Signorelli. Let us now examine separately the two facing cycles.

The cycle that develops along the left wall as one looks towards the altar starts with *Moses' flight into Egypt*, where Perugino depicted in the foreground Moses' meeting with the angel and the circumcision of his second son and in the background the flight into Egypt after taking leave of his father-in-law in the land of Madian.

The second painting, a masterpiece by Botticelli, illustrates with great adherence to the biblical text, some *Facts of the life of Moses*: the killing of the Egyptian who had maltreated an Israelite (below to the right), the flight into the desert (above to the right), the meeting with the daughters of Jethro (in the centre), the episode of the burning bush (above to the left) and the departure from Egypt (below to the left). The succeeding fresco, the work of Biagio di Antonio, depicts the episode of the *Crossing of the Red Sea*. By Cosimo Rosselli is the next painting with the *Consignment of the Tables of the Law*. In the succeeding fresco Botticelli depicts the

Precedentig page. *Reconstructive drawing of the Sistine Chapel in the Quattrocento. At the time of its consecration in 1483, the ceiling of the chapel appeared as a simple star-studded sky tinted in blue (executed by Pier Matteo d'Amelia and replaced in the Cinquecento by Michelangelo) which gave greater prominence to the iconographic programme below: the gallery of the Popes between the windows and the facing cycles of Moses and Christ on the side walls.*

Left. *External view of the Sistine Chapel from the Vatican Gardens.*

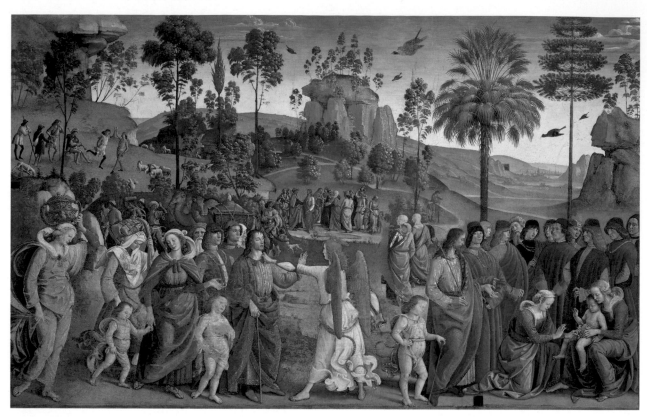

Sistine Chapel. Perugino, Journey of Moses in Egypt.

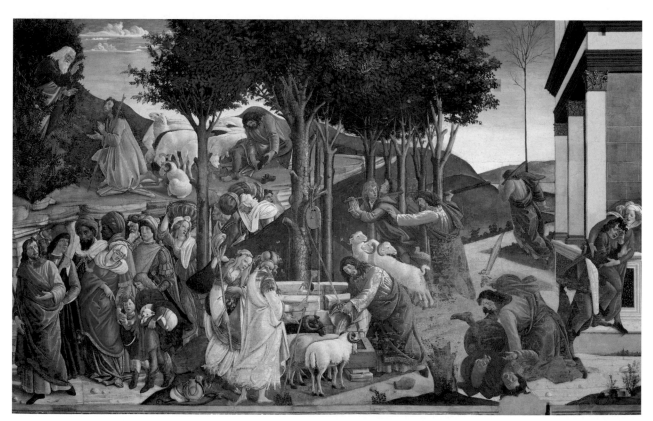

Sistine Chapel. Sandro Botticelli, Episodes from the life of Moses.

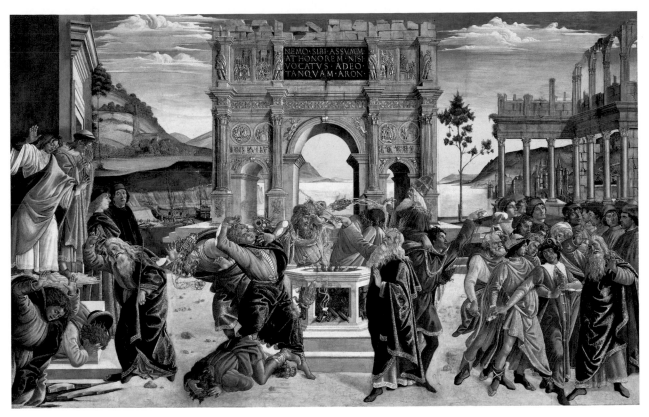

Sistine Chapel. Sandro Botticelli, Punishment of Korah, Dathan and Abiram.

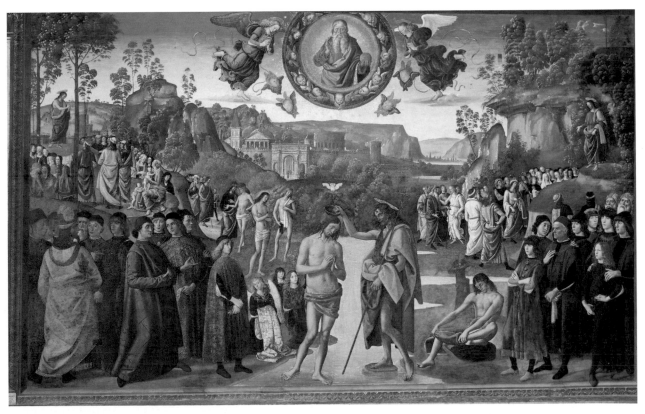

Sistine Chapel. Perugino, Baptism of Christ.

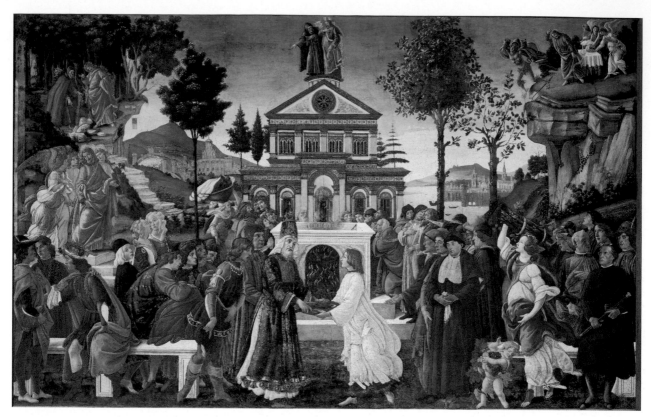

Sistine Chapel. Sandro Botticelli, Temptations of Christ.

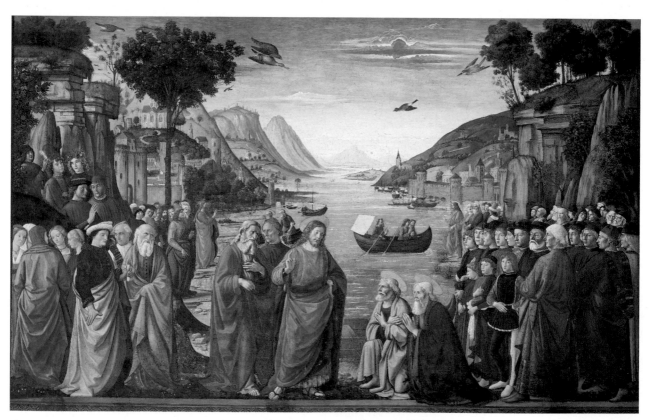

Sistine Chapel. Domenico Ghirlandaio, Vocation of the first Apostles.

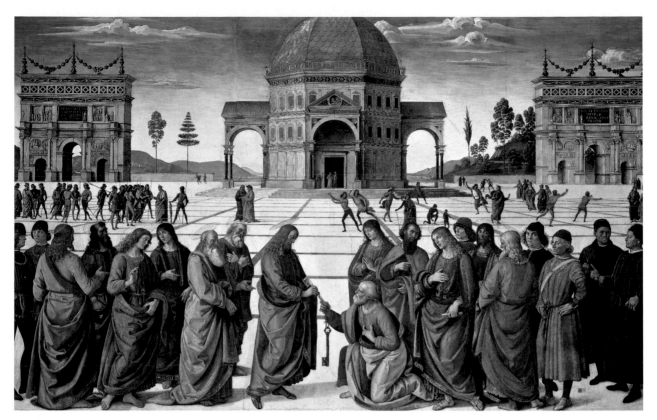

Sistine Chapel. Perugino, Handing over of the keys.

Punishment of Korah, Dathan and Abiram, a subject that is extremely rare in sacred iconography: the three priests, who rebelled against the leadership of Moses and Aaron are portrayed as being consumed by invisible fire and swallowed by the earth that opened up at Moses' signal. The final painting, the work of Luca Signorelli and Bartolomeo della Gatta, depicts the *Testament of Moses* who consigns to Joshua the staff of leadership (to the right in the foreground). The death of the prophet is represented in the left background.

The cycle that develops on the right wall in respect to that of the altar, starts with the *Baptism of Christ*, the work of Perugino and Pinturicchio. The episode is depicted in the centre foreground. In the background the preaching of the Baptist (on the left) and that of Christ (on the right). The subsequent panel, a splendid work by Botticelli, represents the *Temptations of Christ* and the *Healing of the Leper*. The main subject of the temptations is singularly developed in three successive moments in the background, while in the foreground the episode of the purification in accordance with the

tenets of Mosaic law is taking place. To Domenico Ghirlandaio instead do we owe the *Vocation of the First Apostles*, which develops in three scenes. In the foreground Peter and Andrew on their knees are receiving the Lord's benediction, in the background the calling of Peter and Andrew and that of James and John. The successive panel, the work of Cosimo Rosselli and Piero di Cosimo, represents the *Sermon on the Mount* in the centre and the *Healing of the Leper* on the right. The penultimate panel, a masterpiece by Perugino, describes the episode of great symbolical worth of the *Handing over of the keys*, by Christ to St. Peter. The scene, which iconographically illustrates the solemn designation of Peter as head of the Apostles and founder of the Papacy, is represented in the foreground against the background of a great piazza dominated by an octagonal building in the centre and the Arch of Constantine, twice repeated symmetrically on its sides. The concluding panel of the cycle is Cosimo Rosselli's *Last Supper*.

Another grandiose work associated with the name of Sixtus IV is the organisation of the Vatican

TEMPLA·DOMVM·EXPOSITIS·VICOS·FORA·MOENIA·PONTES·
VIRGINEAM·TRIVII·QVOD·REPARARIS·AQVAM·
PRISCA·LICET·NAVTIS·STATVAS·DARE·COMMODA·PORTVS·
ET·VATICANVM·CINGERE·SIXTE·IVGVM·
PLVS·TAMEN·VRBS·DEBET·NAM·QVAE·SQVALORE·LATEBAT·
CERNITVR·IN·CELEBRI·BIBLIOTHECA·LOCO·

Vatican Picture Gallery. Melozzo da Forlì, Sixtus IV, appoints Bartolomeo Platina, Prefect of the Vatican Library (c. 1477). The fresco, commemorating the foundation of the library and the election of its first librarian, was originally situated in Sixtus IV's Latin Library from which it was detached in 1825, transferred onto canvas and exhibited in the Picture Gallery.

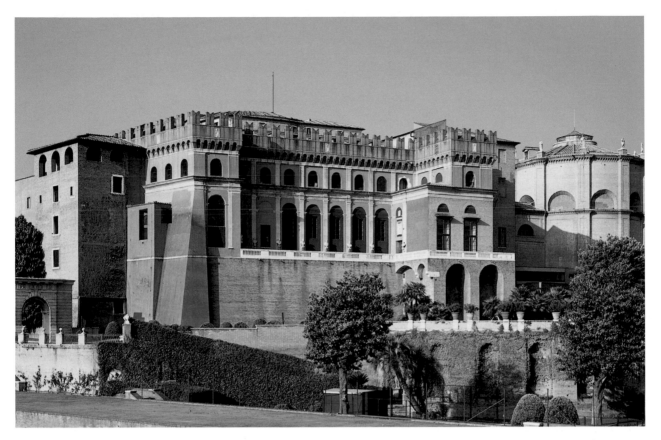

The Palazzetto of Innocent VIII (1484-92). The building constructed by Jacopo da Pietrasanta in the years around 1487, was destined by the Pontiff to be a residence for recreation and repose, a villa true and proper with a spacious open gallery to the south and side turrets. In the Settecento it underwent a radical renovation to become the home, unchanged to this day, of the Museo Pio-Clementino. On the left one sees the structure that houses Donato Bramante's famous spiral staircase which allowed access to the Palazzetto del Belvedere even on horseback.

Library, already planned by Nicholas V, in four rooms on the groundfloor of the Niccoline wing of the Apostolic Palace where there were displayed, rationally subdivided, the four collections (Latin, Greek, secret and pontifical) then existing.

From the catalogue compiled by the first librarian appointed by Sixtus IV, Bartolomeo Sacchi known as Platina, it appears that already in 1481 was putting at the disposal of scholars a patrimony of at least 3,500 manuscript codexes.

His successor Innocent VIII Cybo (1484-1492) extended the confines of the Vatican area, constructing on the hill furthest to the north (*Mons Sancti Aegidii*) a small palace called the Belvedere because of its splendid panoramic position and which today houses part of the prestigious collections of the Pio-Clementino, Egyptian and Etruscan Museums.

The building activities of Alexander VI Borgia,

(1492-1503), the last Pope of the fifteenth century, were concentrated particularly on the strengthening of the defensive system of the Borgo (the area immediately surrounding the Vatican) and of the Palace: it is to him that we also owe the restoration of the ancient entrances to the Vatican (particularly famous is that of the *Porta Sancti Petri*) and the construction of the so-called Borgia Tower which enclosed the fortified quadrilateral of the Apostolic Palace to the north-west. On the first floor of this tower there developed two (the Sala delle Sibille, the Sala del Credo) of the six rooms of the private Apartment of the Pontiff, the famous *Appartamento Borgia*, which with the other rooms occupies part of the fifteenth century wing of Nicholas V (the Sala dei Misteri, dei Santi and delle Arti Liberali) and of the mediaeval part (Sala dei Pontefici).

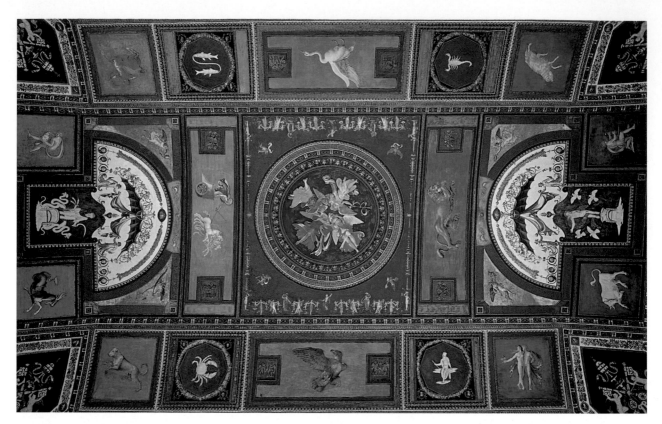

Borgia Apartment. Vault of the Sala dei Pontefici. The mock vault, which around the central tondo with angels dancing represents the twelve signs of the zodiac, the constellations and the seven planets then known, was frescoed by Giovanni da Udine and Perin del Vaga during the pontificate of Leo X (1513-1521) to replace the original beamed ceiling which, collapsing in June 1500, had almost struck down Pope Alexander VI.

THE BORGIA APARTMENT

The decoration of the interior of the apartment was entrusted to Bernardino di Betto from Perugia, better known as Pinturicchio, who worked with the pupils from his workshop from 1492 onwards. The frescoes of the various rooms, finished in the space of only two years in 1494, develop religious and humanistic themes: various mythological scenes find themselves side by side in an unusual manner with the account of the facts of the life of Christ, of the Blessed Virgin and of the saints. A characteristic element is the wide use of ornamentation, gilding, and grotesques[13] which form an elegant surround to the various scenes.

In the first room depictions of the Sibyls and Prophets are painted in the twelve lunettes of the walls. The next room, called the *Sala del Credo*, represents the prophets and apostles in couples between the lunettes, holding in their hands ornamental scrolls bearing verses of the Credo. The *Sala*

delle Arti Liberali takes its name from the mediaeval division of the complex of the so-called liberal arts of the *Trivium* (grammar, rhetoric and dialectics) and of the *Quadrivium* (music, astronomy, geometry and arithmetic). These are represented in the form of splendid female figures enthroned in the lunettes of the walls. The following room, known as the *Sala dei Santi*, is commonly agreed to be the one in which the hand of Pinturicchio is most present and best recognizable. The lunette of the wall facing the window contains one of the maestro's masterpieces: the *Dispute of St. Catherine of Alexandria*, where against the background of an idyllic landscape with trees and softly rolling hills, dominated by the impressive Arch of Constantine, there is the disputation between the saint who intrepidly defends the Christian faith and the Emperor Maximinian, seated on his throne and surrounded by his court. The *Sala dei Misteri*, carried out mostly by the maestro's assistants, represents the principal mysteries of the life of

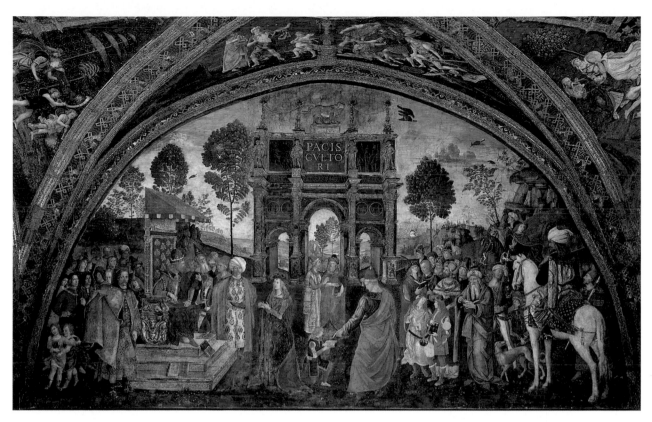

Borgia Apartment. Sala dei Santi. Pinturicchio (1454-1513). The Dispute of St. Catherine of Alexandria before the Emperor Maximinian.

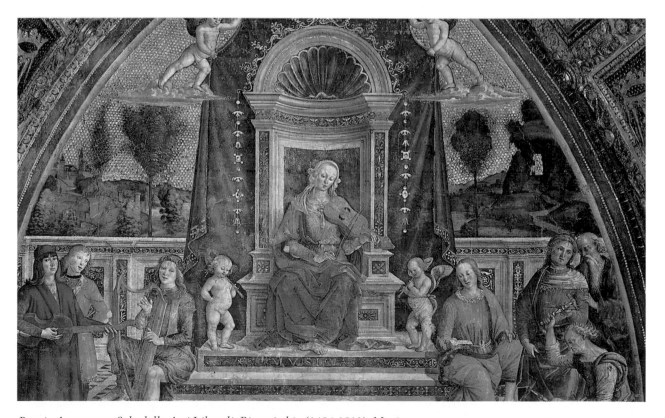

Borgia Apartment. Sala delle Arti Liberali. Pinturicchio (1454-1513). Music.

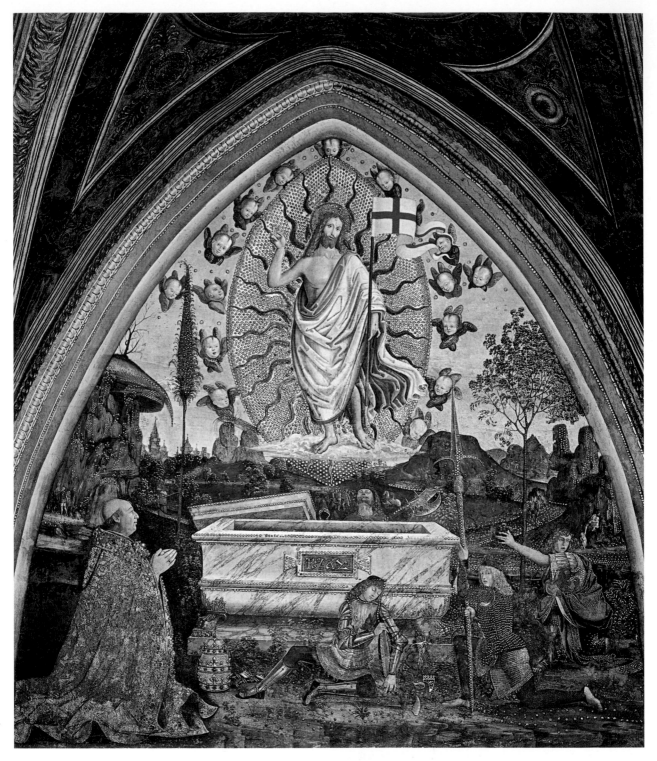

Borgia Apartment. Sala dei Misteri. Pinturicchio (1454-1513). The Resurrection. The Sala dei Misteri is one of the last rooms decorated by Pinturicchio and his assistants. In this setting (which according to some was the dining-hall of the Borgia Pope) the Mysteries of the Faith are depicted in the lunettes. Splendid is the fresco of the Resurrection in which Pope Alexander VI is portrayed kneeling and turning towards Christ ascending in an almond lozenge of golden light.

Christ and of the Blessed Virgin. A splendid achievement is the fresco of the *Resurrection*, with Christ inside a lozenge-shaped area of light studded with golden pearls which is powerfully silhouetted against the background of a splendid Umbrian-like landscape and the portrait of a kneeling Alexander VI. The *Sala dei Pontefici*, which belongs to the fourteenth century wing of the Palace and was used by Alexander VI for official ceremonies, takes its name from the *tituli* above the lunettes. The false ceiling has stucco decoration and grotesques depicting the twelve signs of the zodiac, the work of Perin del Vaga and Giovanni da Udine that can be dated to the pontificate of Leo X (1513-1521).

With Julius II Della Rovere, (1503-1513) there began one of the most fruitful and felicitous periods for the development of the Vatican complex. It was under his patronage that two pictorial cycles that are perhaps the most famous and admired in the Vatican were undertaken: the decoration of the ceiling of the *Sistine Chapel* by Michelangelo Buonarroti (1508-1512) and by the hand of Raphael Sanzio (1509-1517) that of the *Stanze*, situated on the second floor of the Apostolic Palace, which acted as the Pope's private apartments until the end of the sixteenth century.

THE SISTINE CHAPEL. THE CEILING

When in 1508 Pope Julius II entrusted Michelangelo with the task of decorating the ceiling of the Sistine Chapel, the Florentine artist, then thirty-three tried to refuse the commission as he was already involved in the project for the construction of a grandiose funereal monument in honour of Julius II that was to be placed in the renovated St. Peter's Basilica.

Vasari refers to this when he tells us that Michelangelo did all he could to avoid accepting this commission, adding as an excuse his scant practice in painting and seeking "in every way to take this burden from his shoulders, mentioning Raphael first of all as a replacement" (Vasari, *Lives of the Artists*).

The Pope's desire was paramount and Michelangelo started to work on the great undertaking in May 1508. The original idea was somewhat simple and consisted of the representing twelve gigantic figures of apostles in the corbels, but as can be seen in an autographed letter of Michelangelo, the project appeared to the artist "so poor a thing" that he managed to obtain Julius II's permission to proceed with full freedom of conception. Recent studies have shown that the artist was assisted by the Pontiff himself and by theologians of the pontifical court to give substance to the complex iconographical project that we still admire today.

And so the immense ceiling was transformed into a splendid page on which to record the history of the Universe and of Man, from his fall to his reconciliation with God.

At the centre of an impressive architectural painted structure there are nine Stories from Genesis which, starting from the wall behind the altar, depict the *Separation of Light from Darkness*, the *Creation of the Stars*, the *Separation of the Land from Waters*, the *Creation of Adam*, the *Creation of Eve*, *Original Sin* and three episodes from the life of Noah; *Noah's Sacrifice*, the *Flood*, the *Drunkenness of Noah*.

The scenes are inserted into a cornice flanked by pairs of *Ignudi*, splendid figures of naked young men painted with sculptural ability in ever differing poses, who are supporting garlands of oak branches and acorns (the emblem of the Della Rovere family) and medallions of sham bronze with other biblical stories.

On the sides of the principal scenes, between the spandrels, seated on monumental thrones are five Sibyls and seven *Prophets*, who foretold the coming of a redeemer, the former in the pagan world, the latter in the Judaic. In contrast with the Seers (the *Sibyls* and the *Prophets*), because they are ignorant of the Revelation, Michelangelo represented in the spandrels and lunettes the series of *Christ's Forebears*, depicted in small family groups, follow-

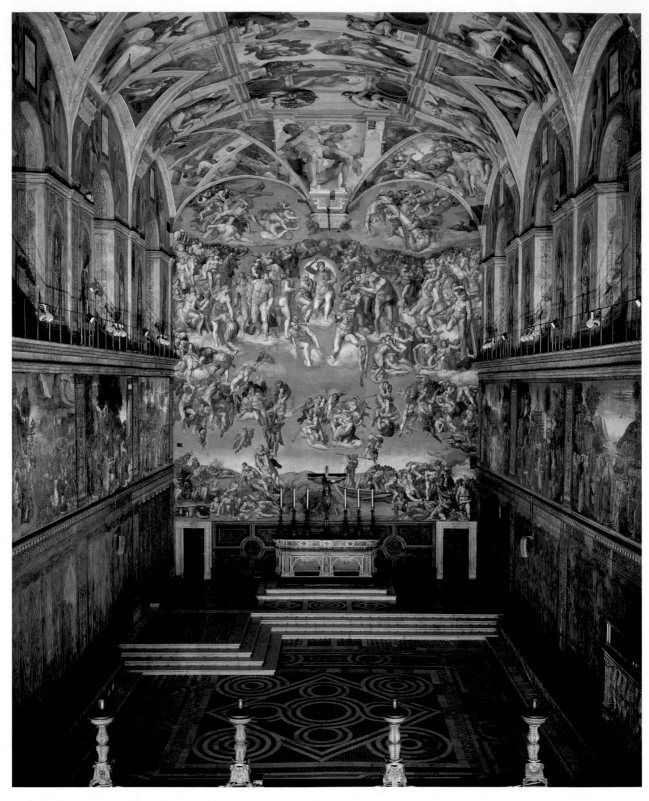

Sistine Chapel. General view looking towards the altar wall.

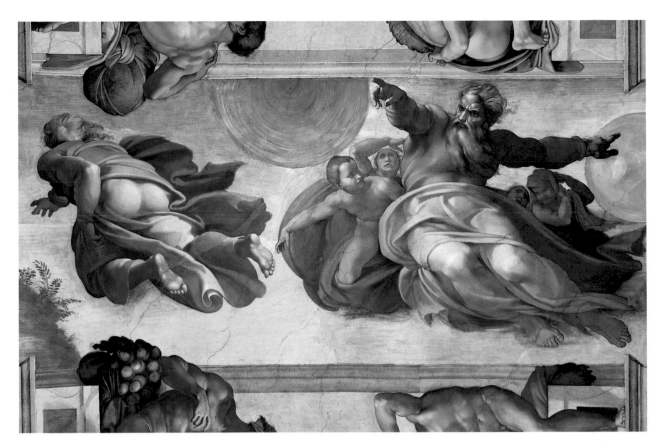

Sistine Chapel. Ceiling. Michelangelo (1475-1564). One of the nine central panels with the stories of Genesis, depicting the Creation of the sun, the moon and the plants.

Following pages. Sistine Chapel. Ceiling, The Creation of Adam. Painted in 1512, perhaps the best known scene of the entire ceiling is one of the undisputed artistic masterpieces of all time and certainly one of the highest points of Michelangelo's whole composition.

ing the sequence from Abraham to Christ listed at the beginning of Matthew's Gospel.

In the great corner spandrels Michelangelo wished instead to represent the stories of the four biblical heroes (David, Judith, Esther, and Moses), in whose undertakings it is possible to perceive God's intervention for the salvation of the chosen people: *David and Goliath*, *Judith and Holofernes*, the *Punishment of Haman* and the *Brazen Serpent*.

"In the light of Renaissance theological thinking, the ceiling of the Sistine Chapel can be read as a grandiose celebration of the work of God who, by moulding Man in His image and likeness, placed him at the centre of all creation, and through the mystery of the Incarnation conferring upon him a higher dignity and one closer to the sphere of the divine" (Carlo Pietrangeli, I *dipinti del Vaticano*, texts by Guido Cornini, Anna Maria De Strobel, Maria Serlupi

Crescenzi, Udine, Magnus, 1996, p. 266).

The entire decorative programme of the ceiling is intentionally associated with the fifteenth century stories of the life of Moses and of Christ: the various divisions of the ceiling can be read as "prefiguration" of the New Testament scenes depicted on the walls below.

In October 1512 the decoration of the ceiling was completed. This is what Michelangelo wrote in a letter to his father: "I have finished the chapel I was painting: the Pope is very satisfied with it".

On All Saints' Day 1512 the Chapel was solemnly inaugurated by the Pontiff. For the first time Michelangelo's frescoes were completely unveiled to the public and they made an incredible impression on his contemporaries. Vasari wrote: "to the wonder and astonishment of the whole of Rome, or rather the whole world and I along with the whole world was stupefied by what I saw".

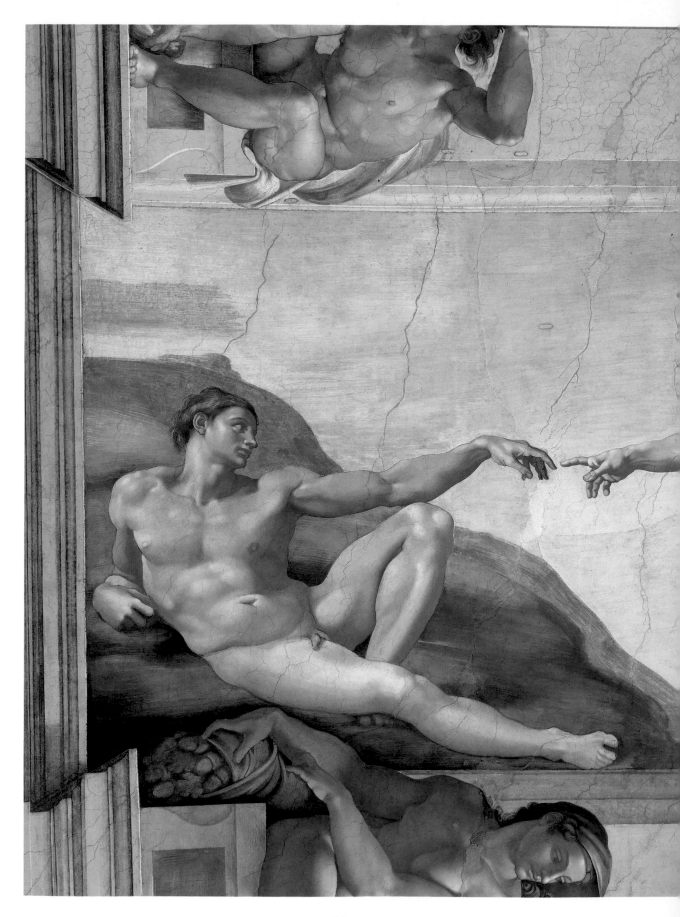

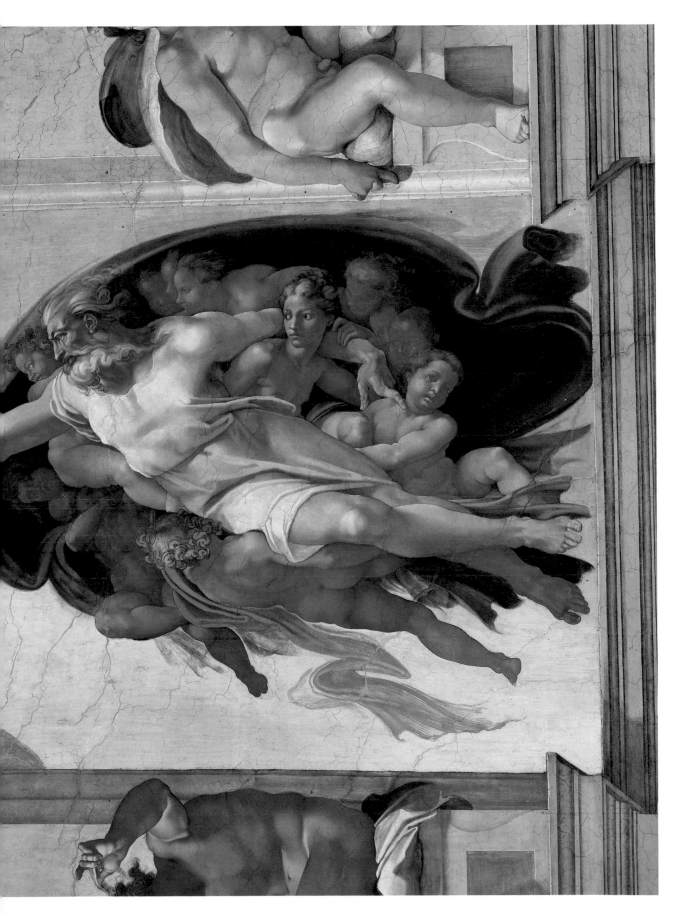

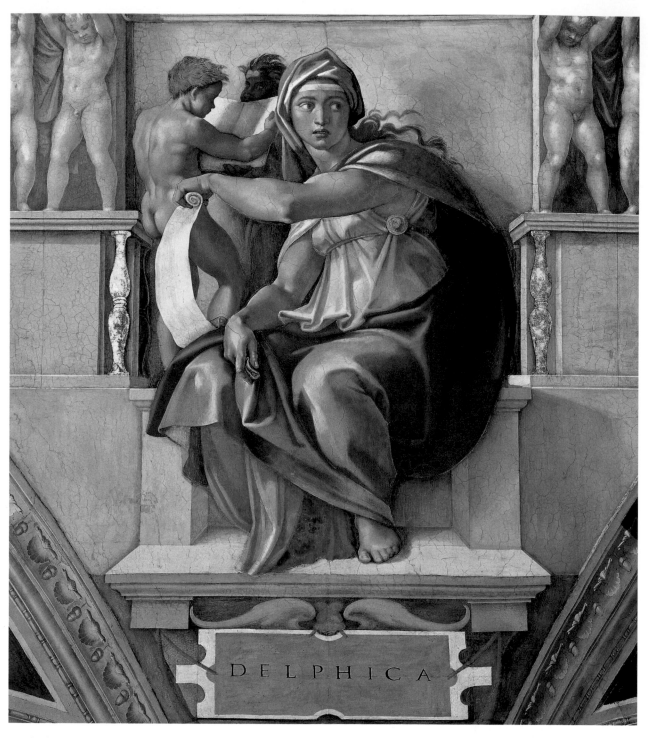

DELPHICA

At the base of the imposing architectural structure conceived for the ceiling, Michelangelo frescoed five Sibyls and seven Prophets who foretold to the world the coming of the Redeemer. The Delphic Sibyl, frescoed to the right of the Drunkenness of Noah, is the most admired of the series because of the beauty of the features. In the ancient world there was a widespread belief that there existed some special interpreters of the divine word, exclusively of the female sex, the so-called Sibyls, through whom the divinities uttered oracles or predictions. From the site of the oracle of Apollo in Delphi it took the name of the Delphic Sibyl.

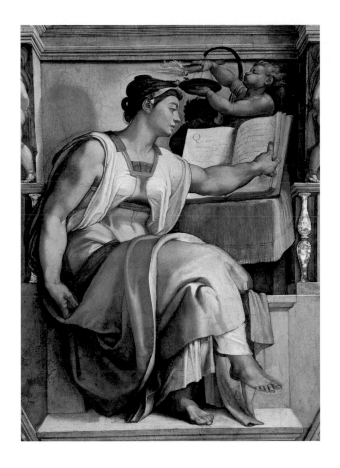

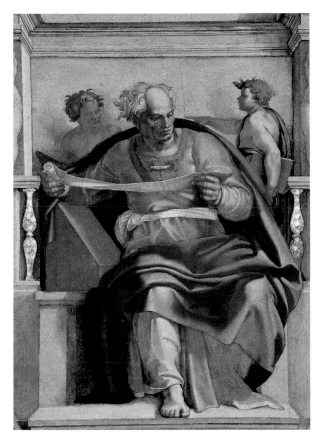

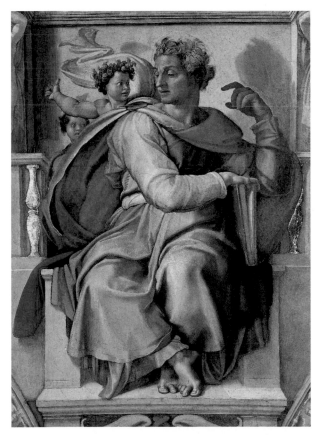

Above left. *To the left of the Sacrifice of Noah Michelangelo frescoed the splendid and noble profile of the Erythraean Sibyl, taken in the act of turning the pages of a volume resting on the lectern.*

Above right. *On the left of the Drunkenness of Noah, the Prophet Joel seems to be seeking attentively the meaning of the prophecy in the scroll which he is holding in his hands.*

Left. *In contrast to the Erythraean, Michelangelo has portrayed the Prophet Isaiah in the attitude of one who is responding readily to the divine call.*

Spandrel of Judith and Holofernes. Here Michelangelo has portrayed the well-known biblical episode of Judith, who by means of a strategem managed to kill the leader of the Assyrian forces, Holofernes, who was laying siege to her city, thus achieving its salvation.

Below. *Spandrel with the Brazen Serpent. Michelangelo has represented the biblical episode described in the Book of Numbers (21, 4-9) which tells how Moses managed to intercede with the Lord, obtaining liberation from the poisonous serpents sent as a punishment to the rebel people of Israel.*

Following page, above. *Detail of one of the central scenes of the ceiling depicting the Flood. On the left of the fresco Michelangelo has represented with great descriptive ability the pathos of those who are trying vainly to escape their tragic destiny. In the background Noah's Ark, which in its form seems to allude to the Church, ark of salvation of mankind.*

Following page, below. *Detail of the central panel of the ceiling with the representation of Original Sin. Here Michelangelo has succeeded in synthesizing in a single picture the two moments of the Temptation and the Expulsion from Paradise using as dividing element the Tree of the Knowledge of good and evil, around which the serpent with female features is coiled.*

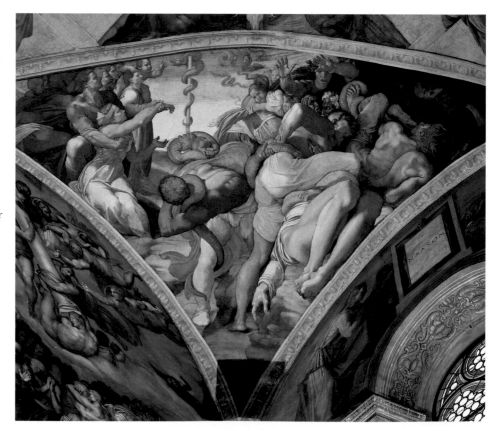

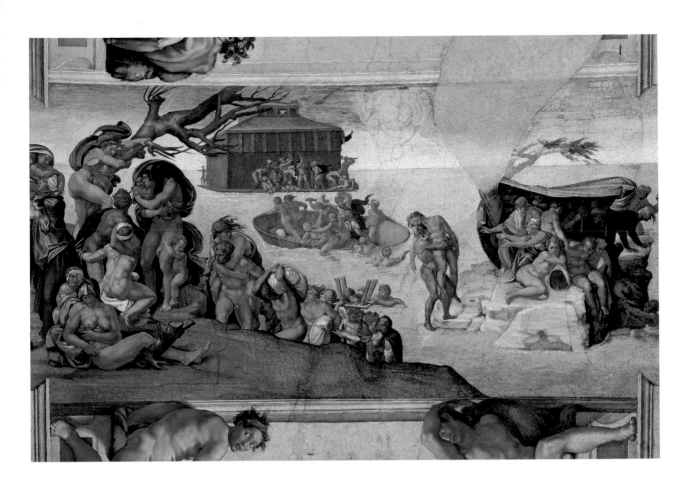

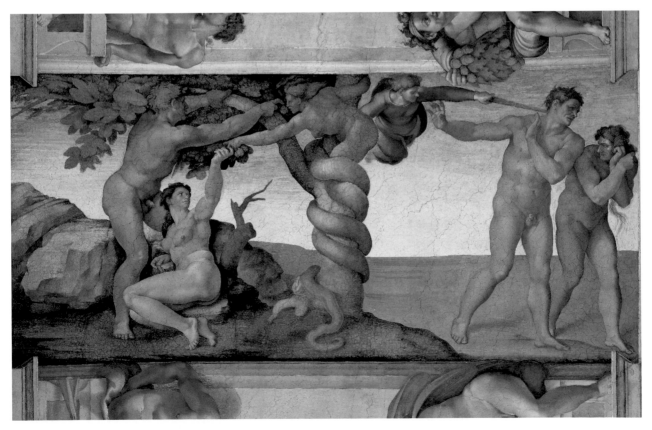

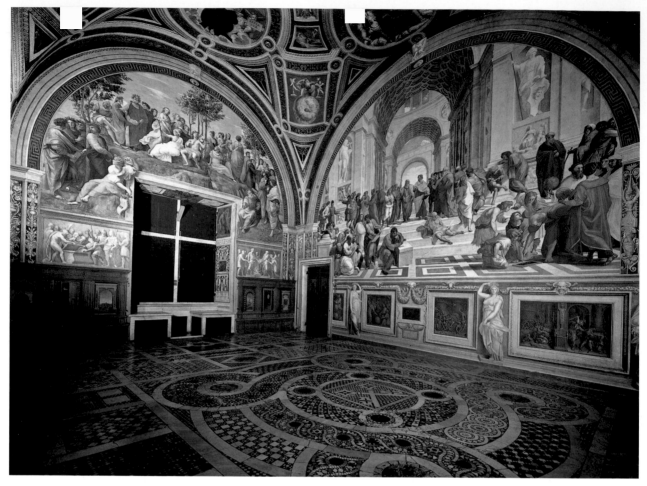

Foreshortened view of the Stanza della Segnatura. Raphael Sanzio (1483-1520). On the right is visible the fresco of the School of Athens, while above on the left one sees the Parnassus.

RAPHAEL'S STANZE

The so-called Stanze of Raphael consist of only four rooms (the *Stanza dell'Incendio, della Segnatura, di Eliodoro, di Costantino*) and are situated on the second floor of the Apostolic Palace, corresponding to the Borgia Apartment on the floor below.

It was to here that Julius II decided to move his private residence in 1507, not wishing to live in the apartment of his wretched predecessor, the Borgia, Alexander VI. For the decoration of the *Stanze*, in 1507 the Della Rovere Pope summoned a band of artists, among the best of the day, such as Perugino, Sodoma, and Lorenzo Lotto. But after having put them on trial in the decoration of the room that was to become the *Stanza della Segnatura*, the young

Raphael arrived in Rome in 1508 and the Pope, struck by the ability of the painter from Urbino, decided to have all that had been done up to then obliterated (all that was spared was Perugino's ceiling in the *Stanza dell'Incendio*), entrusting to Raphael exclusively the decoration of the entire apartment.

The Stanza della Segnatura

It is called this because it was here that the ecclesiastical tribunal "Segnatura della Grazia" met, and it was the room that Raphael first started to fresco.

The pictorial cycle, commenced towards the end of 1508 and completed in 1511, follows a very precise iconographic programme, certainly elaborated

by the Curia that proposed exalting the three fundamental ideas of the human soul: Truth in its twofold aspect of revealed truth (theology), celebrated in the fresco of the *Disputation of the Sacrament*, and of natural truth (philosophy), exalted in the *School of Athens*; Goodness in the theological and cardinal virtues, represented in a lunette called precisely *Virtues*, and in the double canonical legislation, is depicted in the fresco with *Gregory IX approving the Decretals* and civil legislation, represented in the scene with *Justinian giving the Pandects to Trebonianus*; and finally Beauty, represented by Poetry, celebrated in the fresco of *Parnassus*.

On the ceiling on which Raphael wished to preserve Sodoma's original partition and central octagon, the allegorical figures in the four tondi repeat the themes explained on the walls below: corresponding to the Disputation is the tondo depicting *Theology*, to the School of Athens that of *Philosophy*, to Parnassus that of *Poetry*, while corresponding to the lunette of the Virtues and the scenes relating to canon and civil law, we find the medallion with *Justice*. Allegorical scenes relating to the same categories are represented in the corner panels alongside the medallions. They represent *Adam and Eve*, the *Judgement of Solomon*, the *First movement* and *Apollo and Marsyas*.

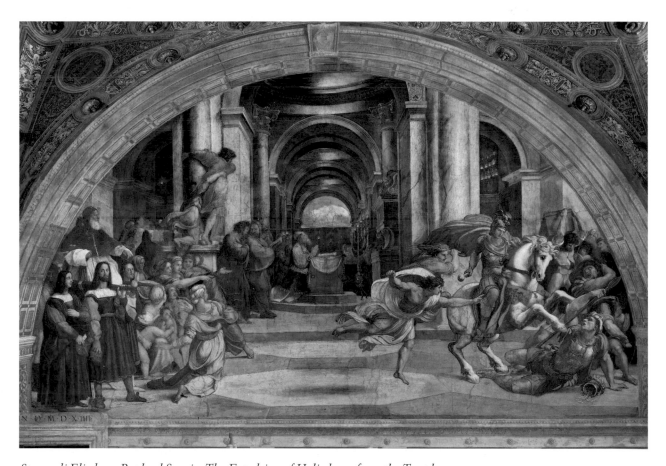

Stanza di Eliodoro. Raphael Sanzio, The Expulsion of Heliodorus from the Temple.

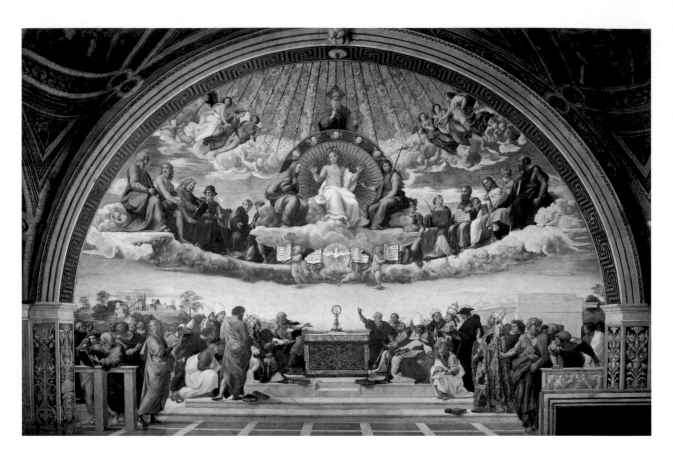

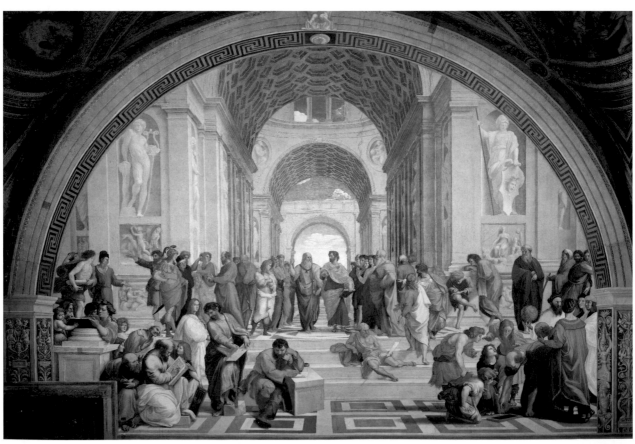

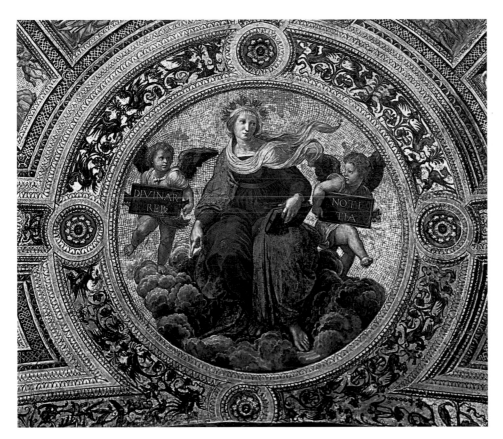

Preceding page, above. *Stanza della Segnatura, Dispute of the Sacrament. The Stanza della Segnatura is the first room decorated by Raphael between 1509 and 1511. It was used by Julius II as a study and a library.*

Preceding page, below. *Stanza della Segnatura. The School of Athens. Against the background of an imposing edifice that seems to echo Bramante's ideas for the new St. Peter's Basilica, a large group of thinkers of bygone ages, the fulcrum of which is the couple Plato-Aristotle, the former portrayed in the act of indicating the heavens, the latter with the palm of his hand pointing to the earth, to indicate the two opposing philosophical conceptions.*

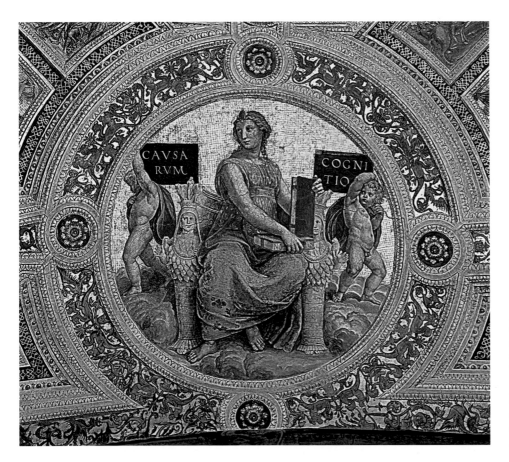

Left, above. *Stanza della Segnatura, Ceiling. Medallion depicting Theology.*

Left, below. *Stanza della Segnatura, Ceiling. Medallion depicting Philosophy.*

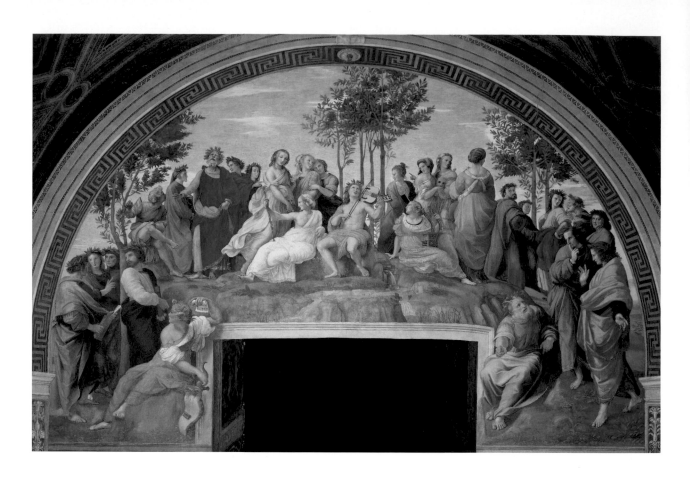

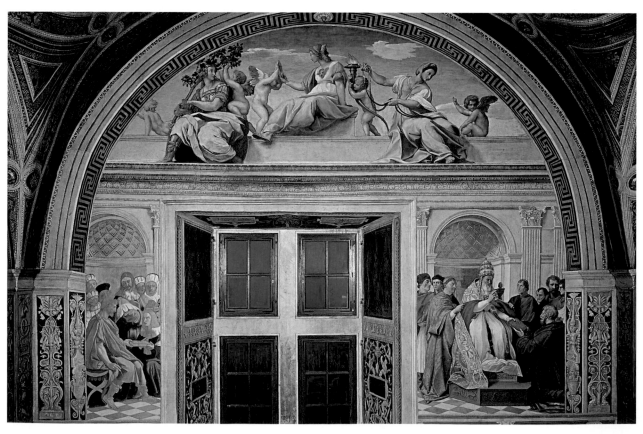

Preceding page, above.
Stanza della Segnatura, Lunette with Parnassus. At the centre of the fresco on the summit of the hill Raphael has portrayed Apollo, seated, intent on playing the lyre, surrounded by the Muses and numerous poets. Easily identifiable on his right, the blind Homer, Dante and Virgil. Seated lower down with an ornamental scroll bearing her name, the Greek poetess Sappho.

Preceding page, below.
Stanza della Segnatura. Lunette of the Virtues.

Left, above.
Stanza della Segnatura, Ceiling. Medallion depicting Poetry.

Left, below.
Stanza della Segnatura, Ceiling. Medallion depicting Justice.

The Stanza di Eliodoro

Immediately after the completion of the Stanza della Segnatura, Raphael worked from 1511 to 1514 in the Stanza di Eliodoro thus named because of one of the frescoes painted on the walls. The theme of the room this time is historical and is an attempt to depict God's intervention in favour of the Church, probably in accordance with a theme proposed by Julius II himself. Four episodes are recounted in it: the *Mass of Bolsena*, *Heliodorus' Expulsion from the Temple*, the *Deliverance of St. Peter* and *Attila's Meeting with Leo the Great*. The base is decorated in chiaroscuro with allegorical caryatids attributed to Francesco Penni following drawings by Raphael. On the ceiling, around the central medallion with the coat of arms of Julius II, are depicted episodes that recall divine intervention in the history of Israel: the Burning Bush, The Sacrifice of Isaac, Jacob's Ladder and the Lord's Apparition to Noah. In this cycle the work of assistants appears more extensive than that seen in the Stanza della Segnatura.

The Stanza dell'Incendio di Borgo

This is the last stanza on which Raphael worked from 1514-1517, where the hands of Raphael's assistants are much more clearly evident in the frescoes compared to the first two rooms. The iconographic programme in this case too is historico-political and represents important events in the pontificates of Leo III (795-816) and Leo IV (847-855) - *L'Incendio di Borgo* (the fire in the Borgo), which gives its name to the room, the *Battle of Ostia*, the *Coronation of Charlemagne* and the *Justification of Leo III*. The choice of subjects is not casual since it clearly exalted the pontificate of the then Pope Leo X (1513-1521) who in fact had his own features depicted in the faces of two distant predecessors. The subject of the base fresco on the wall opposite the main entrance is believed to be chiefly the work of Giulio Romano; it represents yellow monochrome figures alternating with chiaroscuro caryatids. Giulio Romano is also credited with the Egyptian telamons[14] painted in the corners of the room, and inspired by the originals discovered in Tivoli in those years (1504) and exhibited in the Pio-Clementino Museum. The only surviving part of the decoration preceding Raphael's work is Perugino's splendid ceiling which in four tondi depicts complex allegories referring to the Most Holy Trinity (1507-1508).

The Stanza di Costantino

The room was frescoed between 1517 and 1524 (in particular after 1520, the year of Raphael's death) by the principal apprentices from his workshop, Giulio Romano and Francesco Penni, who probably followed preliminary sketches prepared by the maestro. The historico-political themes that had already been adopted in the stanze of Heliodorus and of the Fire were naturally continued here. On the suggestion of Pope Leo X, under whose pontificate the cycle was begun and later to be completed under that of Clement VII, the four frescoes dedicated to the first great Christian Emperor (The *Apparition of the Cross*, the *Battle of the Milvian Bridge*, the *Baptism of Constantine* and the *Donation of Rome*) aim to exalt the triumph of Christianity over paganism. The scenes are depicted in the form of tapestries fringed with gold fixed to the walls, around which another complex decorative procedure is followed with Pontiffs enthroned between allegorical figures and angels supporting papal coats of arms. On the base other episodes from the life of Constantine painted in monochrome alternate with caryatids supporting the coat of arms of the Medici. The original beamed ceiling was replaced in 1585 by the present false ceiling,

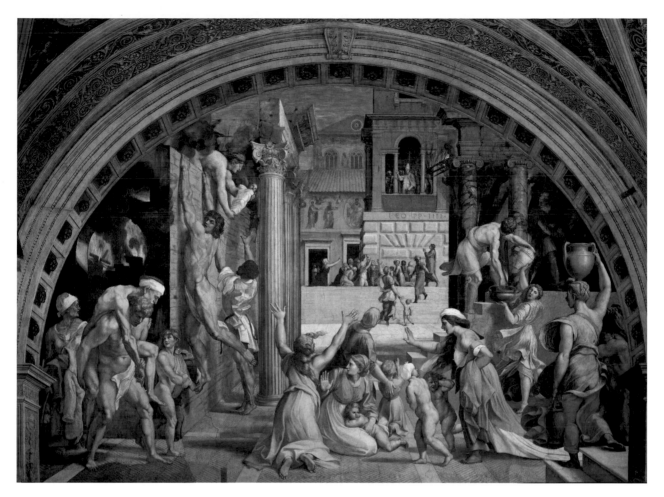

Stanza dell'Incendio di Borgo. Raphael and assistants, Incendio di Borgo. The episode narrated in the Liber Pontificalis goes back to the year 847 and refers to the providential intervention of Pope Leo IV who with his benediction extinguished a fire that had unexpectedly broken out in Rome's Borgo quarter. In the background the façade of the old St. Peter's Basilica.

sumptuously decorated by Tommaso Laureti and his assistants.

It was to the architect from Urbino, Donato Bramante, that Pope Julius II entrusted the solution of the problems connected with the external aspect of the Vatican structure which, under his directives, assumed the aspect we can still admire today, despite the restorations of later periods. The plan of restructuring that the Della Rovere Pope proposed and agreed upon with Bramante articulated around three main points: the connection of the Apostolic Palace with the Palazzetto del Belvedere, by means of a grandiose courtyard (known as the Belvedere) delineated by two long "corridors" of which the architect succeeded in building only the one to the east; the renovation of

the eastern façade of the Nicholine Palace facing the city with the overlapping of three loggias placed in accordance with the classical vitruvian order[(15)]; and finally the plan for the reconstruction of the new basilica of St. Peter's whose foundation stone was laid on the 18th of April 1506 and which was to be completed only 120 years later with the solemn consecration by Urban VIII on the 18th of November 1626.

Julius II, who succeeded Pope Leo X Medici (1513-1521), on the death of Bramante appointed Raphael to continue the work initiated by the maestro. The artist from Urbino, very closely following Bramante's plan, completed the Loggias and began the decoration of the interiors which was later completed by his pupils.

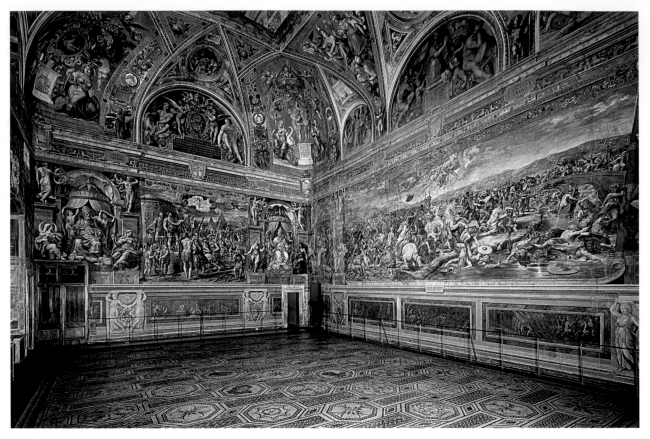

Foreshortened view of the Stanza di Costantino. Raphael's workshop. On the right the fresco of the Battle of the Milvian Bridge is visible, while on the left that of the Apparition of the Cross.

RAPHAEL'S LOGGIA

The so-called *Loggia* of Raphael is constituted by the second floor of the building with three orders of superimposed loggias, planned by Bramante for Julius II as the façade of the Pontifical Palace towards Rome, continued and completed by Raphael who also had the idea of decorating it with stucco and fresco [16]. The interior presents itself as a long gallery divided into thirteen vaults on whose ceilings (between four paintings on each ceiling) Raphael, with his workshop, depicted stories taken from the Old Testament for the first twelve vaults and from the New Testament for the last. The cycle is known as "Raphael's Bible". A rich decoration with stucchi and grotesques of the most varied subjects (mythological scenes, flowers, fruit, animals) carried out on the pilasters and walls is for the most part attributed to the work of Giovanni da Udine and Perin del Vaga. In this sumptuous and very varied ornamentation one can recognise the influence of the ancient examples discovered in the great imperial Roman dwellings, such as Nero's *Domus Aurea*, which then had only recently come to light.

A further phase of constructive fervour took place with the ascent to the pontifical throne of Paul III Farnese (1534-1549). He nominated Antonio da Sangallo the Younger as architect of the Palaces and entrusted him with the renewal of the south-west wing of the Pontifical Apartment. From this re-arrangement sprang two new gems of Italian late Renaissance art - the Sala Regia and the Pauline Chapel. This latter has, amongst other things, the honour of having on its walls the last two frescoes painted by the hand of Michelangelo between 1542 and 1550 at the age of seventy years, the *Conversion of Paul* and the *Crucifixion of Peter*. Only a few years before (1537-1541), always for Pope Paul III, Michelangelo had frescoed his most famous masterpiece, the *Last Judgement*, on the altar wall of the Sistine Chapel.

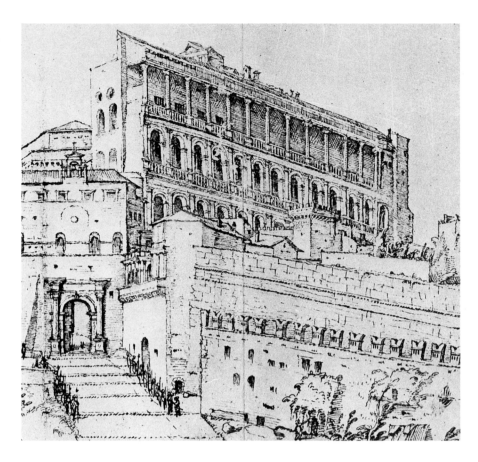

Left. *Detail from a drawing by M. van Heemskerck with the east prospect of the Palazzo Pontificio with superimposed loggias, planned by Bramante and completed by Raphael.*

Below. *The same detail of the preceding drawing as it appears today. Under Gregory XIII Bramante's and Raphael's east prospect was added to with a north prospect, and under Sixtus V an opposite side, thus creating the present Cortile S. Damaso.*

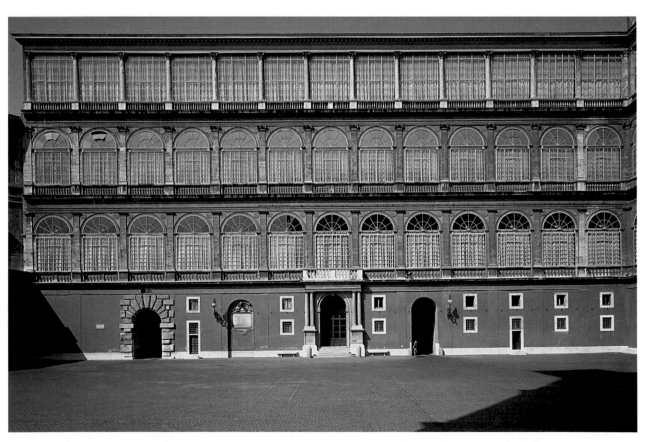

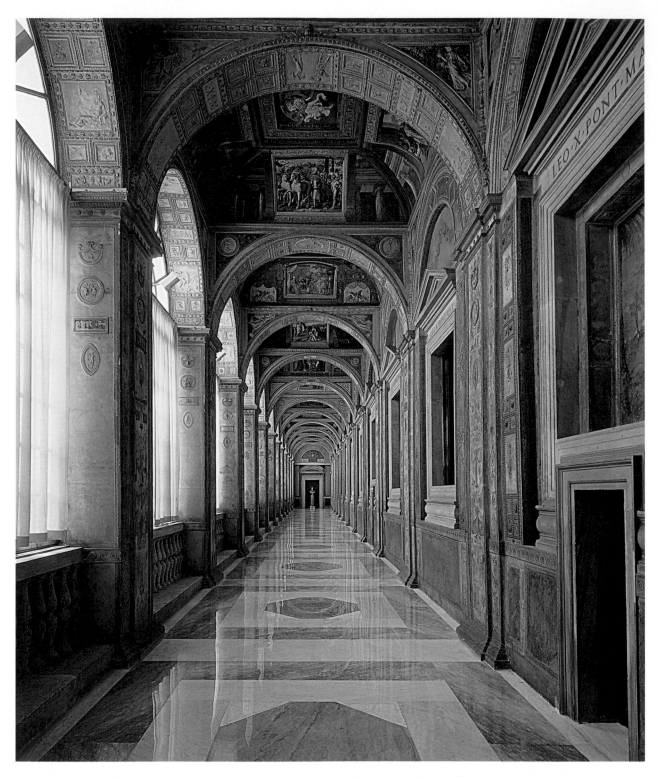

Prospective view of the interior of the Loggia on the second floor, know also as Raphael's Loggia. Raphael began and closely followed the decoration of the central plan of the three open galleries. The other two floors (the first and the third Loggias), even though inspired by the same themes, one (the first Loggia) was decorated in almost the same period by Giovanni da Udine and the other (the third Loggia), much later during the pontificate of Pius IV (1559-65) by Stefan du Pérac and Giovanni Antonio Vanosino da Varese.

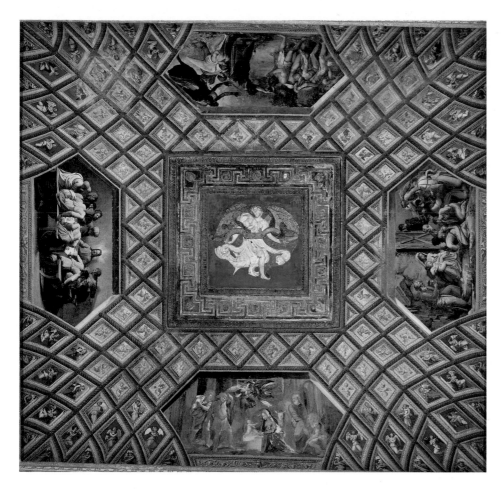

Left. *Raphael's Loggia. Ceiling of the 13th span. Around the central square with an angel in stucco four scenes taken from the New Testament are set. They are the only evangelical scenes of the so-called Bible of Raphael that are displayed on the ceilings of the Loggia's thirteen spans; the other twelve spans each contain four scenes taken from the Old Testament. The four evangelical scenes represented on the ceiling of the 13th span are the following: the Adoration of the Shepherds, the Adoration of the Magi, the Baptism of Christ and the Last Supper generally attributed to the hands of Perin del Vaga and Vincenzo Tamagni.*

Below. *Detail of the festoon decoration of one of the lunettes of Raphael's Loggia.*

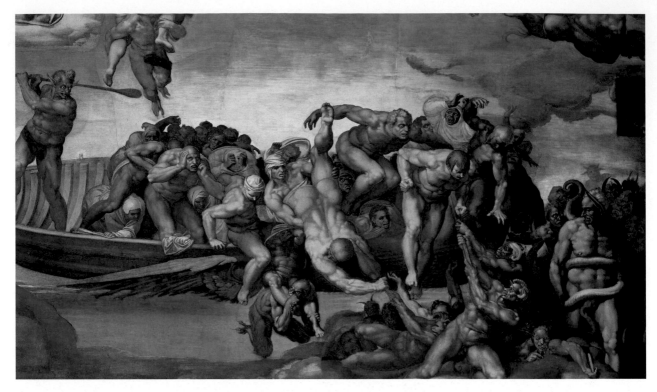

Sistine Chapel. Last Judgement. Detail of the area below right: the infernal ferry-man Charon, the souls of the damned and the infernal judge Minos.

THE SISTINE CHAPEL. THE LAST JUDGEMENT

In 1535, at the age of sixty-five, Michelangelo began to carry out the project, already proposed to him previously by Clement VII (1533), to fresco the entire altar wall of the Sistine Chapel with a majestic scene devoted to the Last Judgement. To do this he had first of all to liberate the immense wall (17 m. high) of the pre-existing frescoes, that is to say, the fifteenth century paintings by Perugino and the lunettes with the Forebears that he himself had painted.

Between 1536 and 1541 under the pontificate of Pope Paul III Farnese (1534-1544) Michelangelo completed this titanic undertaking, painting, alone, some 400 figures who are silhouetted against a blue sky in various attitudes and showing all the nuances of the human soul before Christ the Judge, the central reference of the scene. As Vasari says, Michelangelo "chose always to refuse to paint anything save the human body in its most beautifully proportioned and perfect forms and in the greatest variety of attitudes and thereby to express the wide range of the soul's emotions and joys" (Vasari, *Lives of the Artists*).

The composition is articulated on three distinct levels identified by the groupings of human figures without any architectural partition. In the lowest fascia Michelangelo has represented the damned surrounding the boat of the infernal oarsman Charon and the groups of the dead who, summoned by trumpeting angels, at the centre of the fascia above, rise from their tombs. Depicted around the group of angels with their trumpets, on the opposite sides, demons are in the process of dragging the souls of the damned into Hell while angels are raising the just towards Paradise. In the upper fascia the whole scene is dominated by the figure of Christ the Judge who, with the Blessed Virgin shown at His side, constitutes the focal point of the composition. The Son of Man is depicted with His right hand raised against the background of a sky furrowed with clouds in the act of separating the just from the wicked in accordance with the words of the Gospel of Matthew (24, 30; 25, 32-33):

"They shall see the Son of Man in heaven ... coming in the clouds of heaven with power and great glory. (...) And before Him shall be gathered all

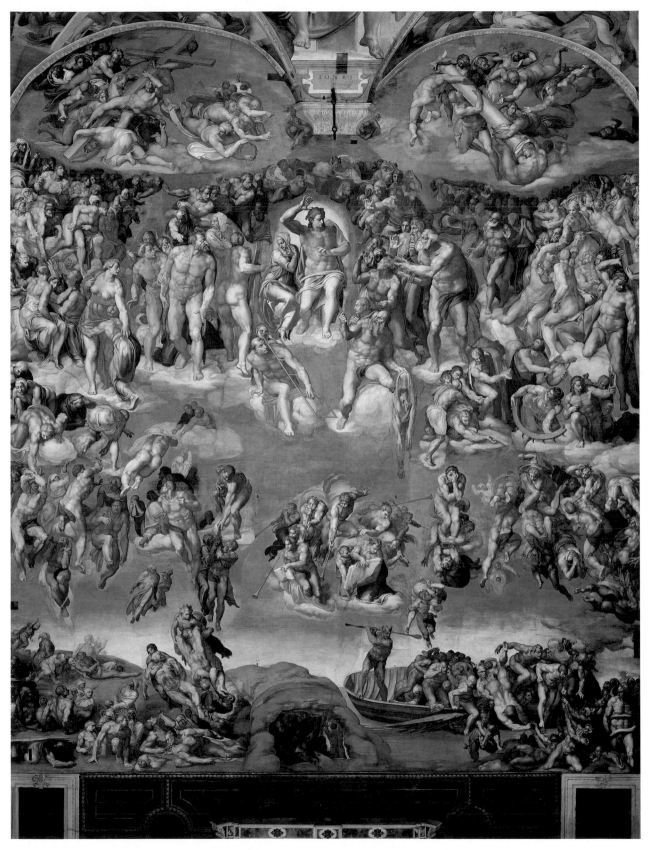

Sistine Chapel. General view of the altar wall with Michelangelo's Last Judgement.

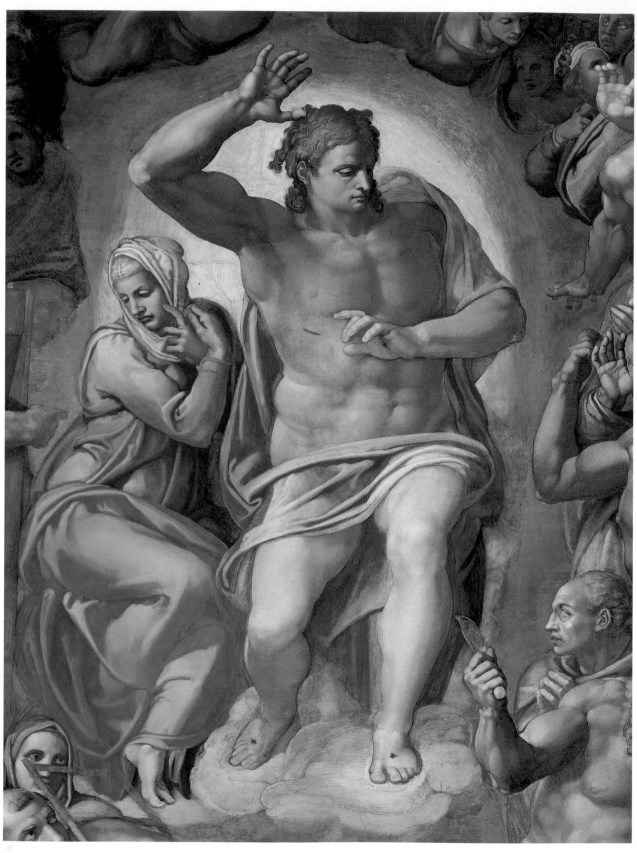

Sistine Chapel. Last Judgement. Detail of Christ and the Virgin at the centre of Michelangelo's composition. Christ is portrayed with His right hand raised in the act of separating the just from the wicked.

nations: and He shall separate them from one another, as the shepherd divideth his sheep from the goats: and He shall set the sheep on His right hand, but the goats on the left".

Around Christ and the Blessed Virgin there is a magnificent circle of saints and martyrs, while in the lunettes above, angels bear the symbols of the Passion.

The fresco, unveiled on All Saints' Day 1541, aroused both admiration and scandal among contemporaries. The harsh condemnation expressed by Biagio da Cesena, Paul III's Master of Ceremonies who followed the Pope onto the scaffolding while the work had not yet been completed is well known, "it is most disgraceful that in so sacred a place there should have been depicted all those nude figures, exposing themselves so shamefully", and judged it to be "no work for a Papal chapel, but rather for the public baths and taverns" (Vasari). Angered by this comment, Michelangelo "determined he would have his revenge; and as soon as he (Biagio) had left he drew his portrait from memory in the figure of Minos, shown with a great serpent curled around his loins, among a heap of devils in hell" (Vasari).

THE PAULINE CHAPEL.
MICHELANGELO'S FRESCOES

The final pictorial undertakings of Michelangelo are the two frescoes decorating the side walls of the Pauline Chapel, so-called because it was desired by Paul III who commissioned Antonio da Sangallo the Younger to construct it.

The two frescoes which represent the *Conversion of Paul* and the *Crucifixion of Peter* and can be considered the spiritual "testament" of the artist, were painted by the seventy year-old Michelangelo, between 1542 and 1550.

In the *Conversion of Paul*, Michelangelo closely follows the text of the Acts of the Apostles (9, 3-7).

Paul is depicted stretched out on the ground after having fallen from his horse, blinded by the divine light that comes from on high. In the background to the right a city can be seen, Damascus, the aim of his journey. The episode of the conversion of the Apostle "persecutor of the nascent Church, struck down and conquered by Christ on the road to Damascus, is the most illustrious example of Grace, of that mysterious gift of God who calls the sinner without any merit and makes of him a just man." (De Campos, *Itinerario pittorico dei Musei Vaticani*, p.146).

In the *Crucifixion of Peter* Michelangelo has depicted the moment of the martyrdom of Peter, who in a manifestation of humility towards Christ, chose to be crucified head downwards according to an ancient tradition. The composition, which is circular, has the Apostle's head at the centre. Splendid is the mastery with which Michelangelo captured the mind of the crowd who, in their anguish, is witnessing without understanding that "from the witness of that martyrdom the future was about to be born: two millennia of history" (Giovanni Fallani).

Under Pius IV Medici, (1559-1565) the architect Pirro Ligorio completed the Cortile del Belvedere, realising the west "corridor", parallel to Bramante's, the southern prospect and the famous "Nicchione" (a wide apse created to replace Bramante's original portico) which completes the northern prospect and still today houses the colossal bronze Pine Cone of the Roman imperial epoch.

To crown the Nicchione in the years 1564-65 he built an elegant semi-circular loggia that recalls the forms of the theatre of Palestrina. It was Ligorio too who created another architectural gem amidst the greenery of the Vatican Gardens: the so-called *Casina di Pio IV* (1558-1563), today the headquarters of the Pontifical Academy of Sciences.

The refined edifice, composed of two main parts connected by an elliptical cortile, a small palace of two storeys and a loggia with nymphaeum and foun-

Interior of the Pauline Chapel. On the first floor of the Apostolic Palace, near the Sistine Chapel, is this chapel designed by Antonio da Sangallo the Younger on the commission of Pope Paul III (1534-49) in honour of whom the chapel takes its name.

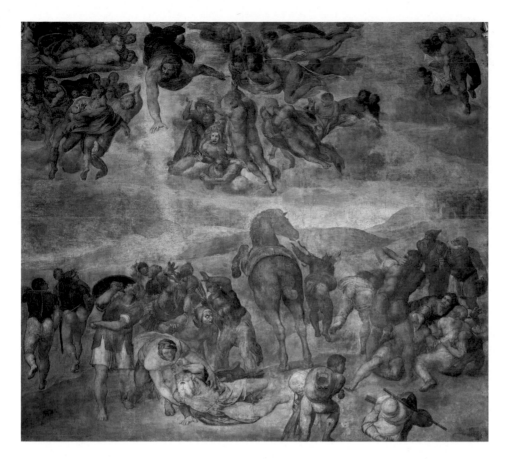

The two great wall frescoes dedicated to St. Peter and St. Paul that adorn the chapel are late works of Michelangelo, who painted them between 1542 and 1550. Here, on the left, is depicted the Conversion of Paul. Below, the Crucifixion of Peter.

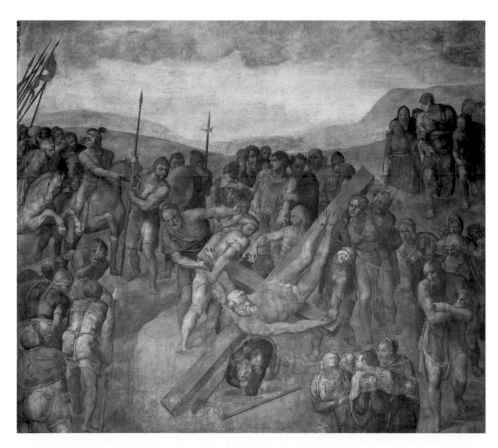

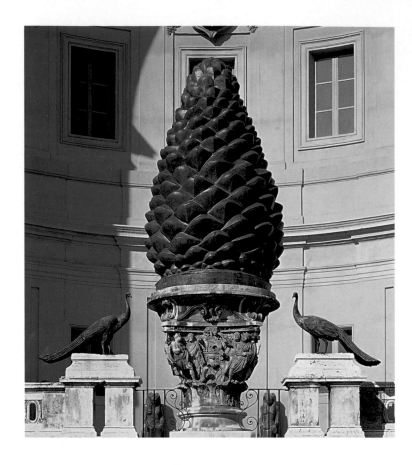

tain is richly decorated on the outside with stuccoes and statues and is a fine example of the Mannerist taste of experimenting classical architectural forms.

During the pontificate of Gregory XIII (1572-1585) the construction of the north wing of the Cortile di S. Damaso (already commenced by Pius IV) was completed under the direction of the architect Martino Longhi who, to make the façade facing the Courtyard uniform to that of the west of Bramante and Raphael, realized a prospect of superimposed loggias similar to those already in existence. To Ottaviano Mascherino Pope Gregory XIII entrusted instead the task of building the *Galleria delle Carte Geografiche* (Map Gallery), on the second floor of the west wing of the Belvedere, and the Torre dei Venti (Tower of the Winds), a rectangular structure on two floors built at the northern extremity of the Gallery itself, to serve as the first astronomical observatory.

Connected to the Torre dei Venti, the Gallery takes its name from the 40 geographical maps frescoed on the two walls in the spaces between the windows and based on cartoons drawn by the noted cosmographer Ignazio Danti, commissioned with this work by Gregory XIII himself.

Other important modifications to the architectural structure of the Vatican complex were made by Pope Sixtus V Peretti, (1585-1590). He entrusted the architect Domenico Fontana with the task of constructing a new Apostolic Palace that added to the east wing of the Cortile di S. Damaso; and so there arose the *Palazzo Nuovo* which still today houses the private apartment (situated on the third floor) and the State apartments (situated on the second floor) of the Pontiff. The construction appears as a massive block on a square plan with internal courtyard whose façade overlooking the Cortile di S. Damaso repeats the structure of superimposed loggias, thus creating *a continuum* with Bramante's prospect and Gregory XIII's north wing. Another important achievement of the architect Domenico Fontana, belonging to the same time span (1587-88), is the construction of the new definitive headquarters of the Apostolic Library: a rectangular structure of very simple forms (70 m. long and 15 m. wide) built on the steps that divided the Cortile del Belvedere, then

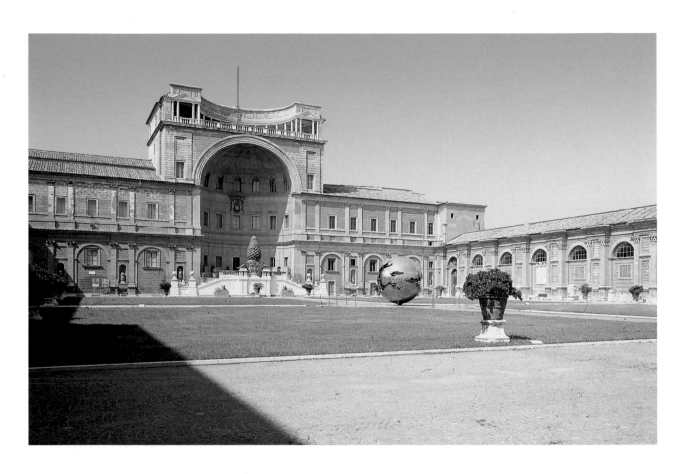

Above. *View of the Cortile della Pigna looking north with the sculpture by A. Pomodoro in the centre and the great Niche in the background.*

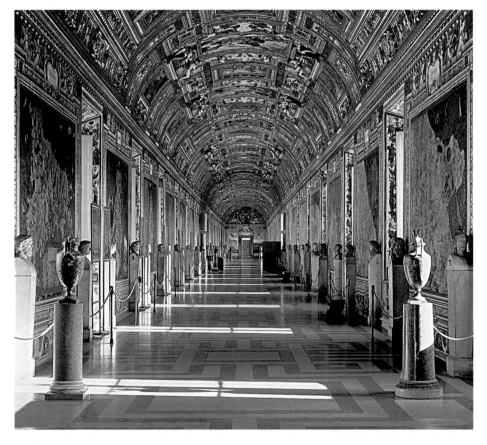

Left. *View of the Galleria delle Carte Geografiche.*

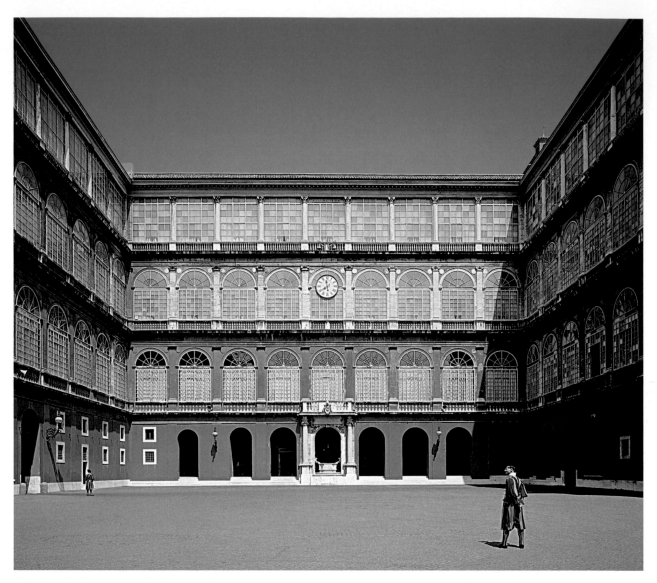

The Cortile di S. Damaso looking north.

known as the Teatro del Belvedere (or Atrio del Piacere), from the Cortile della Pigna of today. The name of Pope Sixtus V is also associated with another impressive undertaking: the completion of that masterpiece of Michelangelo's multiform genius constituted by the Dome of St Peter's, which having been begun by the maestro and raised to the level of the drum, was completed by the architects Giacomo della Porta and Domenico Fontana in the space of three years in 1590. Still due to the impulse of Sixtus V and the genius of Domenico Fontana was the completion in 1568 of a memorable undertaking because of its titanic dimensions: with the use of

about 1,000 men and an impressive wooden scaffolding, the architect succeeded in transporting the obelisk from the circus of Caligula and Nero to the centre of St. Peter's Square, thus completing a project of Sixtus IV and Paul III that had been put aside because of the enormous difficulties involved.

The end of Sixtus V's pontificate marked a period of great building inactivity in the Vatican which was to be resumed only at the end of the 18th century with the construction of the first museum complexes. The main reason for this interruption of building activity was the move, by Clement VIII (1592-1605) onwards, from the Popes' customary residence in the Vatican to

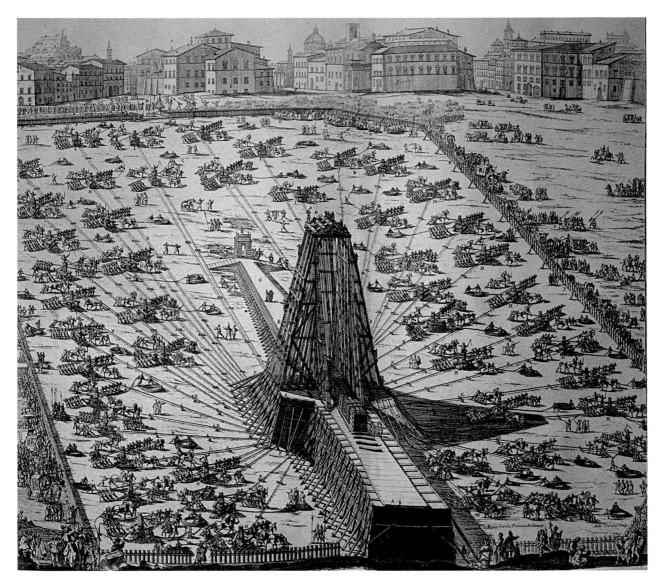

Historic engraving that documents the grandiose enterprise completed in 1586, during the pontificate of Sixtus V (1585-90), of the removal of the obelisk (that had already belonged to the circus of Caligula and Nero) to the centre of the square in front of the Basilica, where it is today. (Photo Archivio Fabbrica di S. Pietro in Vaticano).

the Quirinal, which was considered a more salubrious and functional environment.

In that period of time, however, some important undertakings were completed which, while not modifying the basic order of things, contributed to the creation of the Vatican complex that we can still admire today. It is to Clement VIII Aldobrandini, (1592-1605) that we owe the completion of Sixtus V's Palazzo Nuovo and the decoration of two of its most beautiful rooms: The Sala Clementina (named after him) and the Sala del Concistoro.

With Paul V Borghese (1655-1621), the Baroque made its triumphal entrance into the Vatican. It was under his pontificate that St. Peter's Basilica was completed, whose impressive façade is the work of the architect Carlo Maderno, and the Vatican Gardens were endowed with many splendid fountains.

Under the pontificate of Alexander VII Chigi (1655-1567), the genius of Bernini came into play. His name is linked with the grandiose undertaking of the re-arrangement of St. Peter's Square with the embrace of the Colonnade and the re-modelling of the Scala Regia (the work of Antonio da Sangallo the Younger), the imposing entrance staircase which leads from St. Peter's Basilica to the Apostolic Palace.

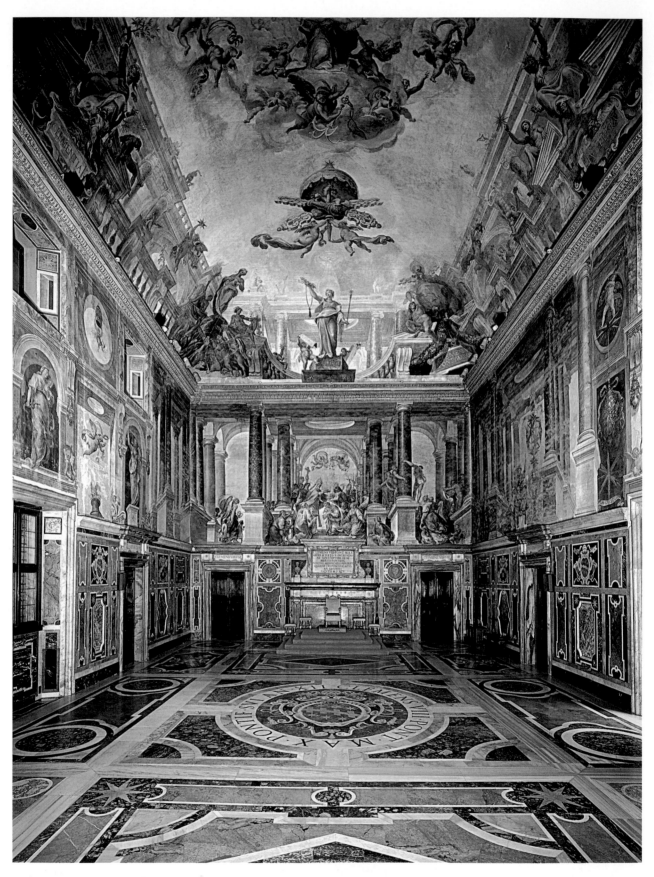

Palace of Sixtus V Sala Clementina.

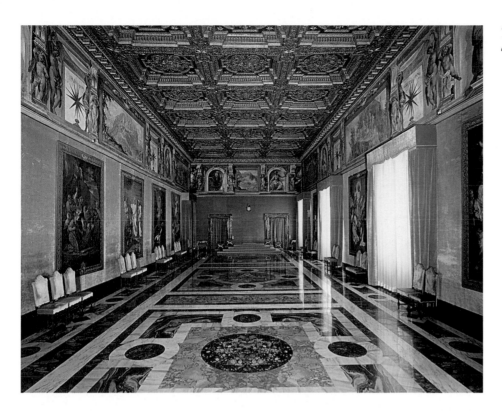

The Palace of Sixtus V Sala del Concistoro.

The Scala Regia of Gian Lorenzo Bernini which leads from St. Peter's Basilica to the Apostolic Palace.

THE VATICAN MUSEUMS

The extensive complex of the Vatican Museums, universally noted for the splendid works of art preserved in them and visited daily by thousands of visitors from all over the world, has a relatively recent history. If it is true that the original nucleus dates back to the beginning of the sixteenth century, for the beginning of the true and proper arrangement, prepared with the intention of giving life to a vast collection, it is necessary to wait until the 18th century when rooms were created which were suitable for receiving and displaying in a rational way the acquisitions of ancient art already in existence which over the years had become ever more considerable.

The sixteenth century nucleus of these collections, that which can be considered the "germ" of the Vatican collections, is owed to the love for classical art of Pope Julius II (1503-1513), already well known as a Maecenas and patron of the pictorial cycles most admired in the Vatican, Michelangelo's frescoes in the Sistine Chapel and those of Raphael in the Stanze. In the inner Courtyard (today the Cortile Ottagono) of Innocent VIII's Palazzetto del Belvedere, in a secluded garden planted with orange trees, he had already begun to collect some of the most beautiful antique statues that were coming to light at that time during the excavations in the subsoil of Rome, including the famous Apollo, later named the Belvedere, and the Laocoön group[17]. This was the start of an exclusive collection of works of ancient art, known as the *Antiquarium*, for the private use of the pontiff and select artists and scholars of that time. Bearing witness of the strictly private nature of this collection it is curious to recall the inscription that appeared above the entrance to the Cortile: *Procul este prophani* "Stay away, you profane ones", a warning quotation from Virgil's Aeneid (Book VI v. 258).

Let us cite part of the description of the Cortile given by the Venetian ambassador visiting Rome in

The helicoidal stairway, planned by the architect Giuseppe Momo and embellished by the bronze balustrade, the work of the sculptor Antonio Mariani, was inaugurated in 1932.

Vatican Museums. The new spiral entry staircase leading to the art collections of the Vatican Museums, inaugurated on the occasion of the Jubilee year 2000.

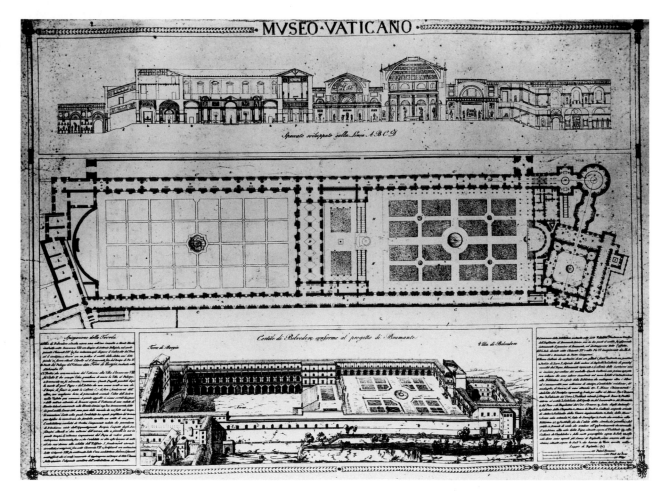

· MVSEO · VATICANO ·

Engraving from the beginning of the 19th century with a section, plan and prospective of the Vatican Museums at the time of Pius VII.

Preceding page, above. *The Antiquarium of Julius II in a 16th century engraving (Bruxelles, Musées Royaux d'Art et d'Histoire).*

Preceding page, below. *Museo Pio-Clementino. Cortile Ottagono. Internal garden of the Palazzetto of Innocent VIII. This cortile, originally with a square ground-plan and planted with orange trees, housed the first prestigious private collection of classical sculpture (Antiquarium) of Pope Julius II (1503-1513), the most splendid of which are still displayed here (Apollo, Laocoön) within the hexagonal spaces known as gabinetti. Restructured in 1722 by Michelangelo Simonetti, it assumed its present octagonal form.*

1523: "And here, having come on horseback, at the end of these loggias one enters a most beautiful garden, half of which is full of fresh grass and laurels, mulberry trees and cypresses; the other half is paved with squares of terracotta edgewise, and from pavement arranged in perfect order. In the middle of the garden there are two very large male figures in marble facing one another — one is the Tiber and the other is the Nile... and from there emerge two very beautiful fountains... "(*Sommario del viaggio degli Oratori Veneti che andarono a dar l'obbedienza a Papa Adriano VI* in E. Alberi, Relazioni degli Ambasciatori Veneti, s.II, vol. II, Florence, 1846, p. 114 et seq.)

And it is starting from this nucleus that Clement XIV Ganganelli (1769-1774) decided in 1771 to create in the Vatican surroundings suitable to receive the ever more numerous acquisitions of classical art, which until then had been kept in the Capitoline Museums. In order to do this the Pontiff

Museo Pio-Clementino,
Cortile Ottagono.
Apollo del Belvedere.
Already present in the
Belvedere in 1509, it is the
most prestigious piece of
Julius II's collection.
A 2nd century Roman copy
of a 4th century B.C. Greek
bronze model that stood
in the Agora in Athens.

Museo Pio-Clementino, Cortile Ottagono. Canova's Perseus. Executed by Antonio Canova in the years around 1800, this statue was acquired by Pius VII in 1802 to make good the loss of the Apollo purloined by Napoleon in 1797.

Museo Pio-Clementino. General view of the Sala a Croce Greca looking towards the Sala Rotonda.

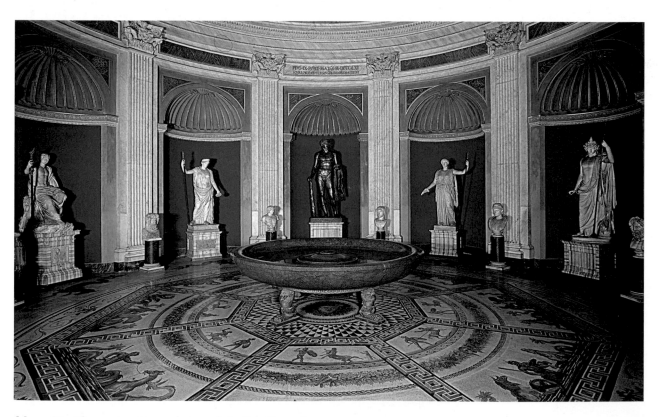

Museo Pio-Clementino. General view of the Sala Rotonda.

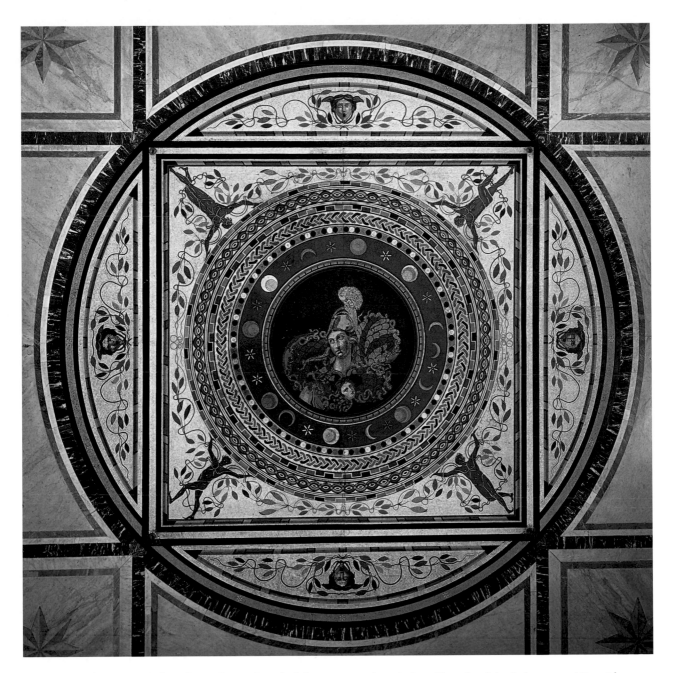

Museo Pio-Clementino, Sala a Croce Greca. Detail of the pavement mosaic from Tusculo of the 3rd century AD. with a bust of Athena-Medusa within a sumptuous 18th century frame. The portrayal of Athena the goddess of war which flanks the face of the Medusa brings to mind the myth of the hero Perseus from Argos who, thanks to the support of Hermes and Athena, succeeded in the fearful enterprise of decapitating the one mortal of the three Gorgons, monsters with hands of bronze and gilded wings, whose very glance turned to stone anyone who looked at them.

Museo Pio-Clementino, Sala delle Muse. In the centre of the room one of the collection's most admired pieces, the so-called Torso del Belvedere. Today the most accredited identification sees in the bust a representation of Ajax who is contemplating suicide. On the block is carved the signature of Apollonius, the Athenian sculptor active in Rome at the end of the 1st century B.C.

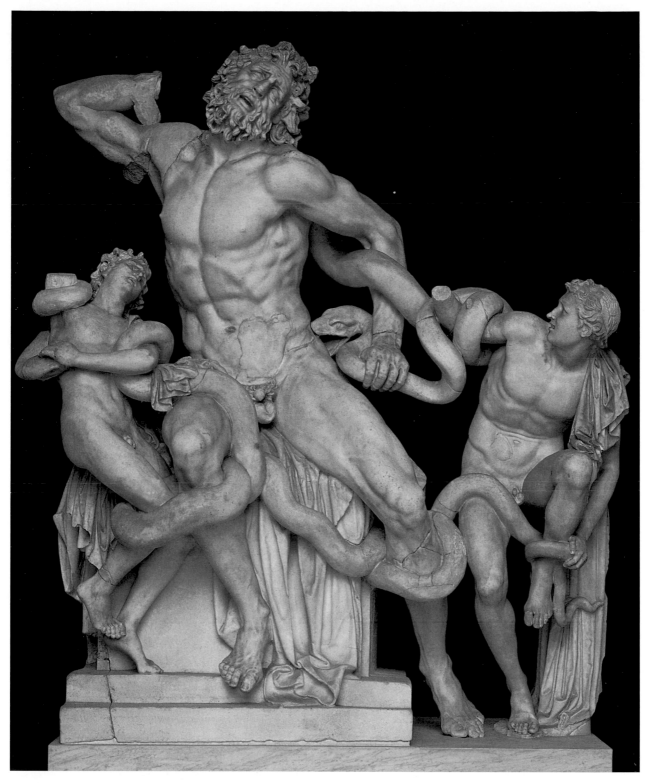

Museo Pio-Clementino, Cortile Ottagono. Laocoön group. Found in 1506 near Nero's Domus Aurea and in the same year acquired by Julius II, this splendid marble group represents the Trojan priest Laocoön and his two sons entwined in the coils of two serpents sent by Athena as punishment for being opposed to the introduction into the city of Troy of the wooden horse in which Greek soldiers were hidden.

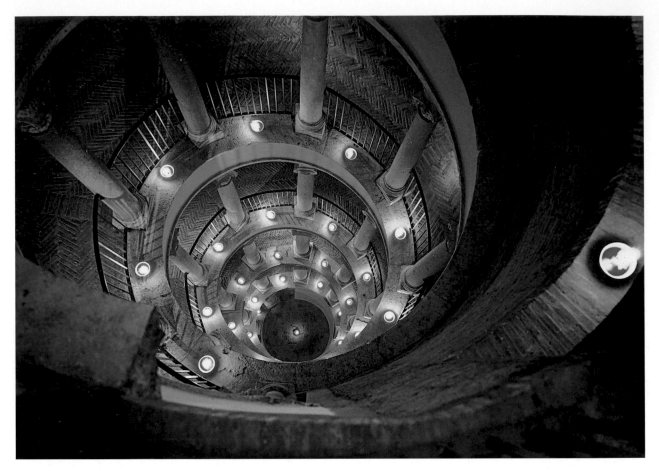

View from above of the inside of the Scala di Bramante (1444-1514). Practicable even on horseback, the spiral staircase, begun in 1512 by Bramante and completed in 1564 by Pirro Ligorio, is composed of 36 columns with bases and capitals in travertine marble arranged in an hierarchical succession of Vitruvian ascendancy in the three orders Doric, Ionic and Corinthian. One can reach it from the entrance hall of the Museo Pio-Clementino.

gave the architect Alessandro Dori the task of transforming and adapting Innocent VIII's Palazzetto del Belvedere in such a way as to make it a structure suitable for the presentation of a museum collection. Dori's work was continued after his death (1772) by Michelangelo Simonetti, appointed Architect of the Sacred Apostolic Palace, to whom we owe the present arrangement in an octagonal form of Julius II's Cortile. Closing the original loggia of Innocent's Palazzetto, the *Gallerie delle Statue* was formed and the collection of classical statuary was placed there, according to the taste of the time, to ornament the surroundings.

But it is above all to his successor Pius VI Braschi (1775-1799) that we owe the completion of the first impressive museum complex in the Vatican, the **Museo Pio-Clementino**, so-called in honour of the two Popes who promoted its realization. Under his pontificate in fact the nucleus of the Clementine Museum was considerably enlarged with the construction *ex novo* of a series of great rooms by Simonetti[18]. The new accomplishments of the architect (the Sala a Croce Greca, Sala Rotonda, Sala delle Muse, Sala degli Animali, Gabinetto delle Maschere) are works of exceptional value that contributed "to recreate in eighteenth century key, the great spaciousness of classical architecture" (Carlo Pietrangeli, *I Musei Vaticani* p. 64). Although following criteria for exhibiting which has now been superseded, the PioClementino is of immense historical value having marked the beginning of a scientific approach to classical antiquities and being the first example of the rational arrangement of the Vatican Museums.

Exterior view of the edifice that contains the Scala di Bramante. Standing against the external wall of the Palazzetto del Belvedere, beside the Scala di Bramante, is one of the most picturesque fountains of the Vatican, the so-called fountain of the Galera (or Galea). It is a man-of-war in copper and lead constructed in miniature by Marbino Ferrabosco and Hans Van Santen, better known as Vasanzio, during the pontificate of Paul V (1605-1621).

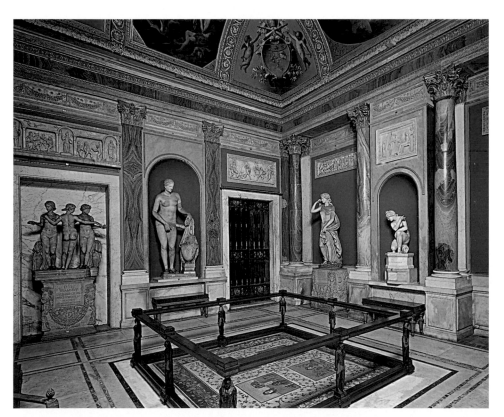

Museo Pio-Clementino. View of the Gabinetto delle Maschere. On the back wall inside a niche the Cnidia Aphrodite, one of the most beautiful copies of Praxiteles' Aphrodite, and on the left, the group of the three Graces (Roman copy of the 2nd century A.D.).

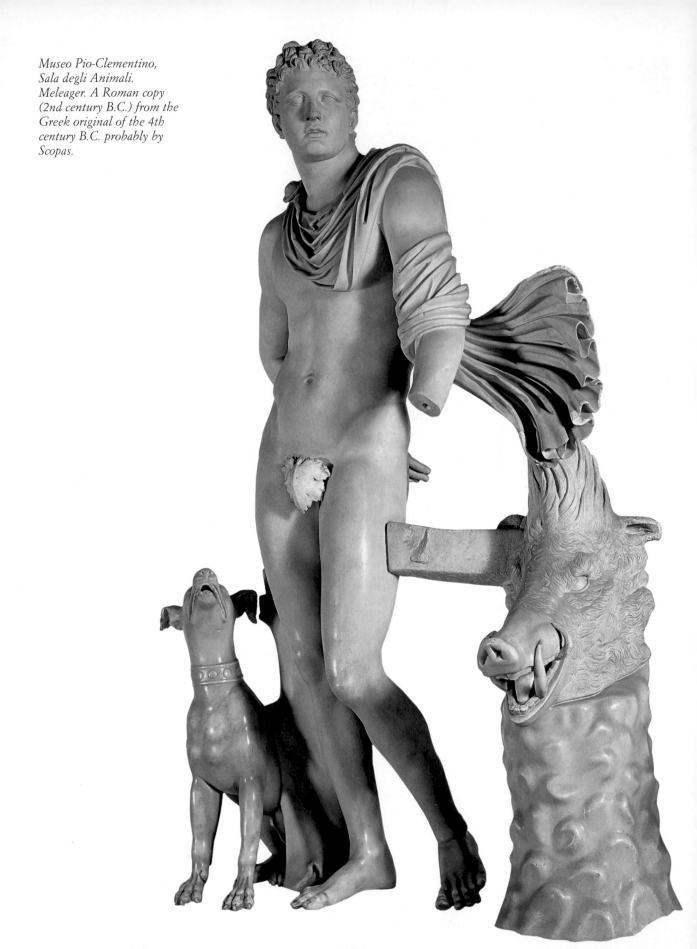

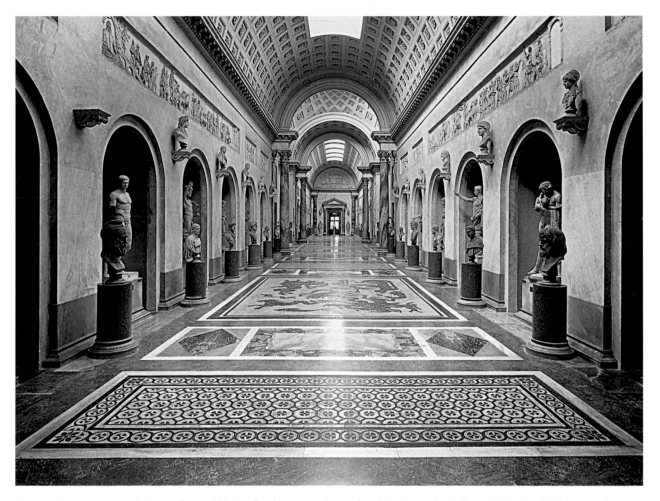

Braccio Nuovo. General view. Planned by Raphael Stern and completed by Pasquale Belli in 1822, this building in the neoclassical manner stands on the south side of the Cortile della Pigna parallel to the Salone Sistino of the Vatican Apostolic Library.

Under his successor Pius VII Chiaramonti (1800-1823), there was the start of various important initiatives to reconstitute the patrimony of the works of art of the Vatican Museums, greatly impoverished by the French following the Treaty of Tolentino (1797). It is above all to the diplomatic ability of Antonio Canova, then Commissioner of Pontifical Antiquities, that we owe the recovery of the greater part of the artistic patrimony of the Vatican following which, with the Congress of Vienna (1814-1815) and the fall of Napoleon, it was established that the works of art plundered by the French should be returned to the States that had been conquered. The growing number of pieces that then started to pour into the Vatican made it necessary to adapt and construct new buildings for the display of objects in the Museums. This was the start of the **Museo Chiaramonti**, which

takes its name from its founder Pius VII Chiaramonti, and the **Braccio Nuovo**, a building parallel to that of Sixtus V's Library, a perfect realization of neo-classical architectural taste, both inside and out, where the works were placed, following Canova's suggestion, with great wisdom and care in the arrangement of their exhibition. Beyond the gateway at the end of the Museo Chiaramonti, on request, it is possible to visit the **Galleria Lapidaria**, which contains, embedded along the side walls, more than 3,000 pagan and early Christian inscriptions which together constitute one of the most important epigraphical collections in Rome.

During the course of the nineteenth century, on the initiative of Pope Gregory XVI Cappellari, (1831-1846), there was the foundation of the **Museo Gregoriano Etrusco** (1837) and of the **Museo Egizio**

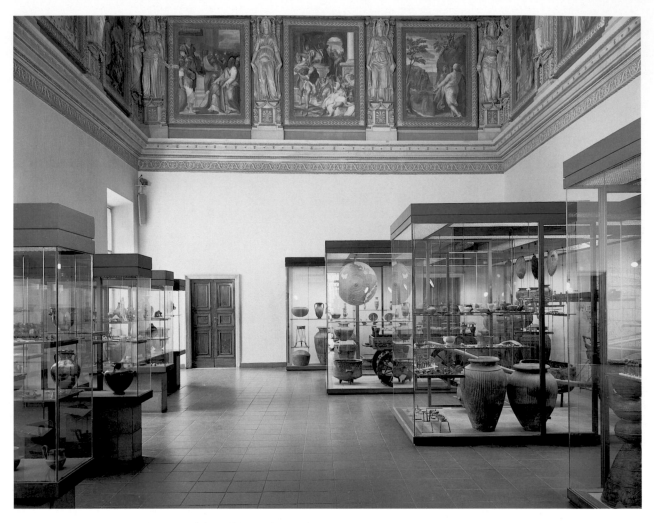

Museo Gregoriano Etrusco. View of the Sala Regolini-Galassi.

(1839), derived from the rooms on the first and second floors of the Palazzetto del Belvedere.

The Museo Gregoriano Etrusco began to develop following the discovery of many Etruscan relics during the excavations carried out in the territory of the Papal States in the first decades of the nineteenth century. Two sensational finds in particular strengthened the decision to insert in the itinerary, until then centred on classical art (Museo Pio-Clementino), a museum dedicated to Etruscan art: the discovery in 1835 of the so-called Mars of Todi, a splendid example of the great bronze Etrusco-Italian art (end of the 5th century B.C.) and the discovery in the necropolis of Cerveteri in 1836 of superb funerary furnishings, almost intact, belonging to the so-called Regolini-Galassi Tomb, from the names of its discoverers. The right of pre-emption[19] to all that was

then discovered, acquired by the Pontifical State following the issue of the Pacca Edict (1820), naturally favoured the growth of the pontifical collection. The Etruscan museum "was the first of its kind to be founded ... but the arrangement, which lasted until 1920, displayed a total lack of interest in reconstructing the furnishings, giving prominence exclusively' to the typological division of the material" (Carlo Pietrangeli. *I Musei Vaticani, cinque secoli di storia*, Rome, Edizioni Quasar, 1985 p. 161).

Even if already it was to the initiative of Pius VII that we owe the commencement of a first small collection of Egyptian antiquities, the birth of the Museo Egizio true and proper is connected with the name of Gregory XVI. The decision to found an institute whose purpose was to collect and preserve works of art of ancient Egypt coincided with a period of

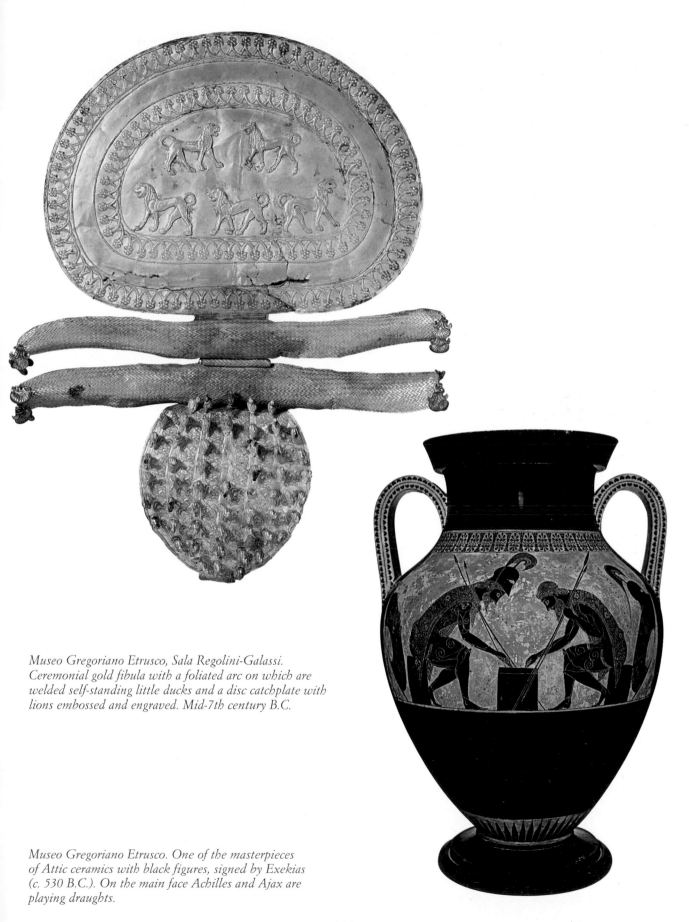

*Museo Gregoriano Etrusco, Sala Regolini-Galassi.
Ceremonial gold fibula with a foliated arc on which are
welded self-standing little ducks and a disc catchplate with
lions embossed and engraved. Mid-7th century B.C.*

*Museo Gregoriano Etrusco. One of the masterpieces
of Attic ceramics with black figures, signed by Exekias
(c. 530 B.C.). On the main face Achilles and Ajax are
playing draughts.*

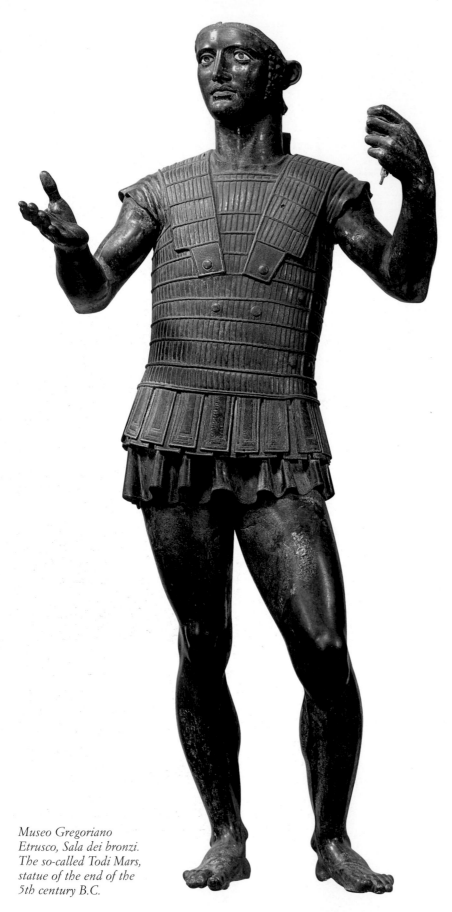

*Museo Gregoriano
Etrusco, Sala dei bronzi.
The so-called Todi Mars,
statue of the end of the
5th century B.C.*

Museo Gregoriano Etrusco, Sala delle urne cinerarie. Funerary monument with the dying Adonis. Tuscania, 2nd century B.C.

Museo Gregoriano Egizio, Sala III. Reconstruction of the "Serapeum of Canopus" of Hadrian's Villa at Tivoli.

Museo Gregoriano Egizio, Emiciclo. Statue of Queen Tuya. Dynasty 19, c. 1250 B.C.

Right. *Museo Gregoriano Egizio, Sala III. Statue of Osiris-Antinöus.*

*Museo Gregoriano Egizio. Historical scarab that bears on
its base the text commemorating the excavation of an
artificial lake (1380/79 B. C.)*

*Falcon, image of the god Horus,
protector of the monarchy.*

Museo Gregoriano Egizio, Sala I.
Stela celebrating work
undertaken by Queen
Hatshepsut and her nephew
Tuthmosis III in the temple of
Karnak. Dynasty 18,
1460 B.C.

Museo Gregoriano Egizio.
One of the two recumbent lions
of Nectanebo I (380-362 B.C.,
Dynasty 30), today by the
colossal bronze pine-cone of
Roman times that gives its
name to the Cortile della Pigna.

Pinacoteca Vaticana, Sala II. Giotto (1267-c. 1337) and workshop. Stefaneschi Triptych (c. 1320). Central panel (recto) with Christ enthroned and lateral panels with the Beheading of St. Paul (right) and the Crucifixion of St. Peter (left).

intense fervour for and interest in Egyptian civilisation: it was from the year 1818 when F. Champollion deciphered the "Rosetta stone" which, unveiling the mysteries of hieroglyphic writing, opened up new frontiers to the study of this fascinating culture. The arrangement of the museum was entrusted to one of the first Italian Egyptologists, the Barnabite priest, Luigi Maria Ungarelli, who re-created the original atmosphere of Egyptian civilisation in a welcoming setting. Of particular interest is the reconstruction of the architecture and statuary of the Serapeum (sanctuary of the divinity Serapis) of Canopus (ancient

Egyptian city near Alexandria) from Hadrian's Villa (Room III) which still preserves a great part of the original nineteenth century decoration.

The **Pinacoteca Vaticana**, which preserves paintings and tapestries from the 11th to the 19th centuries, is today housed in a building constructed by the architect Luca Beltrami, inaugurated by Pius XI in 1932. The history of the formation of this splendid collection is very complex and has its beginnings in the eighteenth century with the creation of a first picture gallery set up at the wish of Pius VI (1775-1799) in what is now the Galleria degli Arazzi. After the

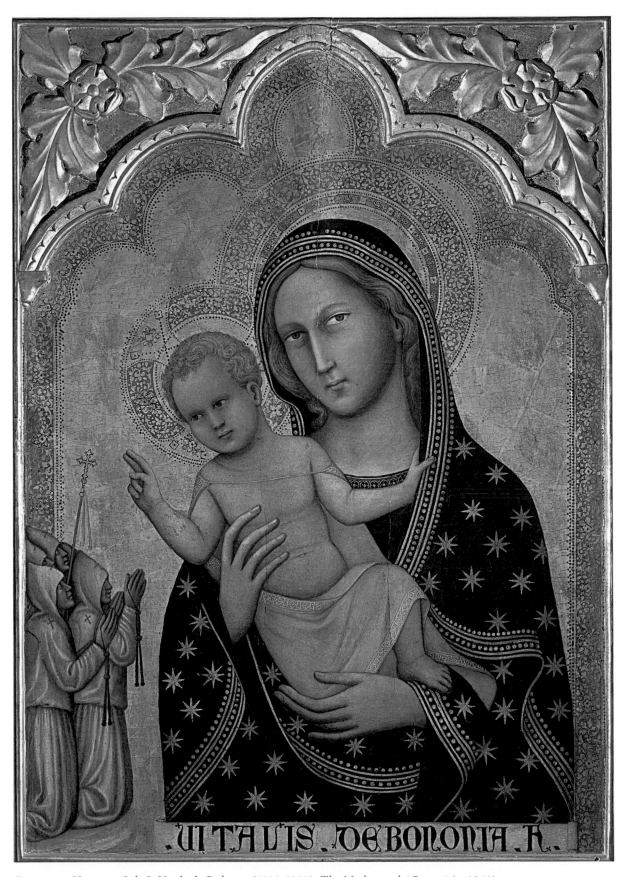

Pinacoteca Vaticana, Sala I. Vitale da Bologna (1309-1359). The Madonna dei Battuti (c. 1340).

Pinacoteca Vaticana, Sala VIII. Raphael (1483-1520). The Transfiguration (c. 1520). Above, Christ between Moses and Elijah, below, the episode of the child possessed of the devil.

Pinacoteca Vaticana, Sala XII. Michelangelo Merisi, called Caravaggio (1571-1610). The Deposition from the Cross (c. 1604).

Treaty of Tolentino (1799), that led to the dispersal of many paintings taken to Paris by Napoleon's troops, the gallery was closed. With the recovery of the greater part of the pieces from the collection following the fall of Napoleon and the Congress of Vienna (1815), Pius VII founded a new Pinacoteca (1817), which remained in the Borgia Apartment until 1822.

From there, after various moves[20], it reached its definitive site under Pius XI (1922-1939). In the sixteen rooms into which it is sub-divided and arranged according to chronological and regional criteria, the Vatican collection contains some of the most famous pictorial masterpieces of all time such as the *Stefaneschi Triptych* by Giotto, Raphael's *Transfiguration* (to which the eighth Sala is devoted), and Caravaggio's *Deposition*, to mention but a few of the most famous.

Transferred to the Vatican to the new wing constructed by the Passarelli brothers behind the Pinacoteca under the pontificate of John XXIII (1958-1963) are the three Museums that were originally set up in the Lateran Palace and which were opened to the public in 1970: the **Museo Gregoriano Profano**, desired by Gregory XVI in

Museo Gregoriano Profano. General view.

Museo Gregoriano Profano.
The Chiaramonti Niobe.
With a chiton tied below
the bosom and her mantle
close to her sides, here is
portrayed one of the
daughters of Niobe,
spouse of the King of
Thebes, Amphion.

Museo Pio Cristiano. Statue of the Good Shepherd. It is one of the earliest representations of Christ, perhaps even dating back to the pre-Constantinian age (3rd century A.D.).
The statue has undergone an extensive and radical eighteenth century restoration.

Left. *Museo Pio Cristiano. Cippus of Abercius. Bishop of Hierapolis in Phrygia, Abercius lived at the time of the Emperor Marcus Aurelius (161-180 A.D.). As well as being the most ancient, this cippus (stone or marble trunk) is one of the most important Christian inscriptions of eucharistic content.*

Below. *Museo Pio Cristiano. Sarcophagus of Juno Pronuba. At the centre of the sarcophagus Juno, the pagan divinity and protectress of matrimony, is portrayed between a married couple.*

1844 which preserves classical works of art, the **Museo Pio Cristiano**, instituted at the wish of Pius IX in 1854 which contains works of ancient Christian art, and the **Museo Missionario-Etnologico**, Museum, founded by Pius XI in 1926 following the world Missionary Exhibition of 1925 with the purpose of exhibiting in various sections, each by geographical area, the different Christian and other forms of religious art from around the world.

The last collection, which became part of the Vatican Museums in 1973, is the **Collezione d'Arte Religiosa e Moderna**, inaugurated by Paul VI (1963-1978). Displayed in the Borgia Apartment, the collection, displays about 800 works of painting, sculpture and graphics, by some of the greatest contemporary Italian and foreign artists such as Gauguin, Matisse, Rodin, Fontana, Morandi and Severini, to mention but a few.

In a spacious locale constructed under the so-called Giardino Quadrato by the Pinacoteca Vaticana is the **Museo delle Carrozze**, founded in 1968, which contains covered coaches (Berlins) that belonged to popes and cardinals, as well as carriages and the first motor-cars used by the Popes.

The Museo Storico Vaticano was recently transferred to the Lateran Palace. It was inaugurated in 1991 and contains objects used in papal ceremonies and the arms and uniforms belonging to the pontifical armed corps.

Collezione d'Arte Religiosa Moderna. Georges Braque (1882-1963), Dove, lithograph. To one of the most significant representatives of the Cubist school, one owes this subtle engraving on stone depicting a stylized dove.

Collezione d'Arte Religiosa Moderna. Henri Matisse (1869-1954), chasuble. To the final period of activity of this many-sided French artist, the major representative of the Fauvist movement, belongs the realization of a series of splendid liturgical vestments with strong and decisive colours that completes the sacred furnishings for the chapel of Vence.

Collezione d'Arte Religiosa Moderna. Auguste Rodin (1840-1917), The Hand of God (c. 1890). In this small bronze (33 x 53 cm.) The French sculptor succeeded in capturing the intensity of the moment of the creation of man and woman.

Below. *Collezione d'Arte Religiosa Moderna. Enrico Manfrini (1917-), Saul (1958). This dramatic bronze sculpture, work of the artist who held the Chair of Sculpture at Milan's Brera Academy, depicts the moment of St. Paul's conversion described in the Acts of the Apostles (9, 3-7).*

Collezione d'Arte Religiosa Moderna. Auguste Rodin (1840-1917), The Thinker (1880-1888). This example in bronze (h. 71 cm.) was cast in 1956 from the principal figure in the Gate of Hell, the sculptor's work inspired by Dante's Inferno.

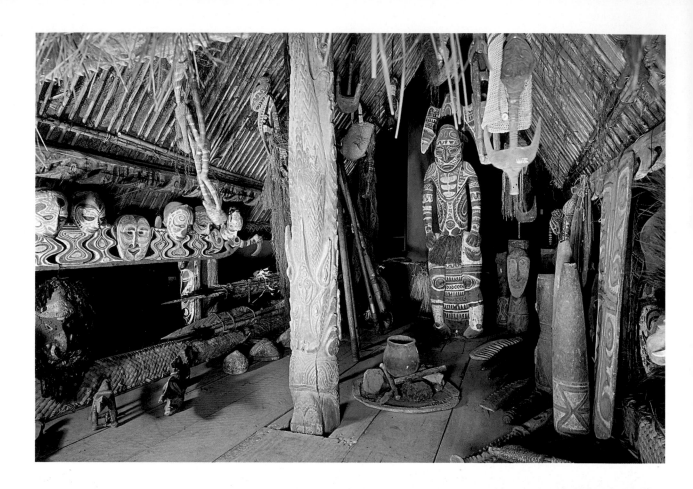

Above. *Museo Missionario-Etnologico, Papua-New Guinea. Interior of the "Tambaran", the ceremonial house that constitutes the spiritual and social centre for the inhabitants of the villages of New Guinea. In the background, the great wooden statue of the god of war. Beside the main supporting pole is the furnace upon which the sacrifices for the spirits were made ready.*

Right. *Museo Missionario-Etnologico, China. One of the two "Takuchai" (guardian lions) in enamel coming from Beijing. The lions represent the two essential principles of Chinese philosophy and religiosity, the ying and yang, which together constitute the tao (supreme law).*

Museo Missionario-Etnologico, Central America. Mexican sculpture in reddish stone depicting the god of the wind, Quetzalcóatl ("plumed serpent"), in classical Aztec style (15th century).

THE VATICAN GARDENS

A splendid crowning to the beauty contained in the 44 hectares of the Vatican State are the wonderful gardens which, enclosed within the mighty sixteenth century wall fortified with bastions, cover almost half of the entire territory.

This is a magnificent green oasis, with a wealth of multiple and rare varieties of trees, plants and flowers wisely arranged so as to form pleasing splashes of colour right in the heart of the city of Rome.

Making the spectacle truly unique and impressive are the many splendid fountains, fed by water from Lake Bracciano. Among those that stand out are those dating back to the pontificate of Paul V (1605-1621), built by Martino Ferrabosco and Giovanni Vasanzio, such as the *Fontana del Sacramento* (1609) and the *Fontana dell'Aquilone* (1612).

Another spectacular fountain, perhaps less well-known because it is situated at the edge of the gardens true and proper[21] is the *Fontana della Galera*, thus called because of the bronze man-of-war (galera) made by Giovanni Vasanzio (1621), from the muzzles of whose cannons arranged along the sides there spurt continuous jets of water that inspired some verses by the future Pope

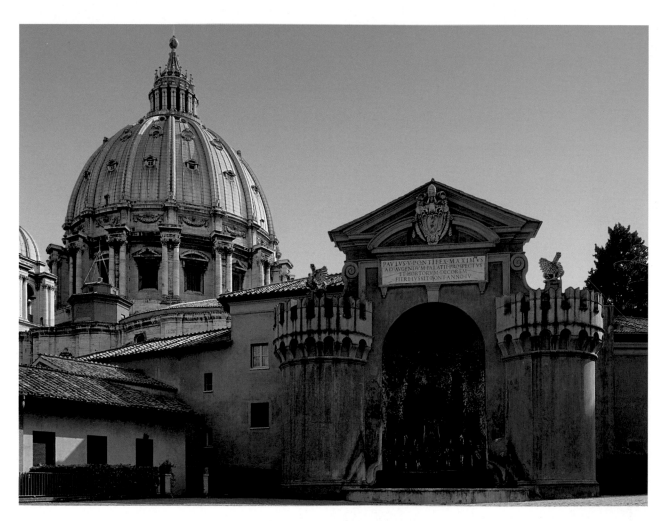

Vatican Gardens, Fontana del Sacramento. So called because of its water jets that remind one of altar-candles.

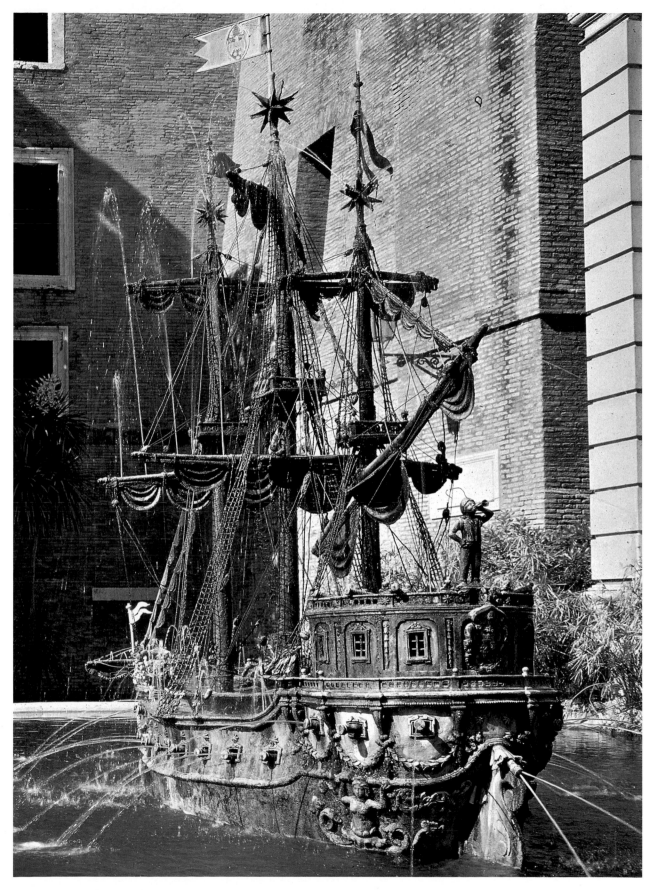

The Fontana della Galera at the foot of the Scala del Bramante.

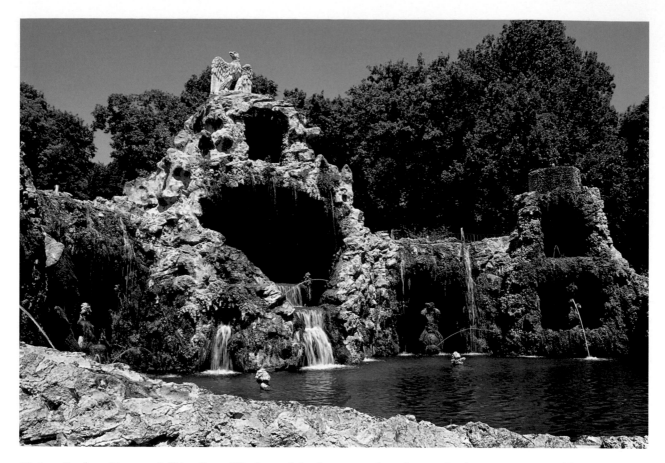

Vatican Gardens, Fontana dell'Aquilone. The form of the fountain is that of an artificial grotto surmounted by an eagle, while below two dragons are spouting water into an oval basin. Eagle and dragons together constitute the coat of arms of the Borghese family, to which Pope Paul V (1605-1621) belonged and under whose pontificate the greater part of the fountains of the Vatican Gardens were constructed.

Urban VIII: *Bellica Pontificum non fundit machina flammas/Sed dulcem belli qua perit ignis aquam*, "The Pontifical man-of-war does not spout flames, but rather fresh water that quenches the fire of war"[22].

An architectural gem placed amidst the greenery of the gardens is the so-called *Casina di Pio IV*, today the headquarters of the Pontifical Academy of Sciences. This articulated building in the mannerist taste, the work of Pirro Ligorio (1558-1563), is composed of a villa and a loggia, connected by a fine elliptical cortile with an elegant fountain in the centre. The external walls are completely covered with mosaics, frescoes, and extensive stucco decoration that develops subjects drawn from classical mythology. The interior, which is also decorated in stucco, has niches with ancient statues in line with the classical taste of the whole complex.

To the west of the Casina di Pio IV, in the Torre Leonina which belongs to the surviving stretch of Leo IV's walls, there is the Directorate of *Vatican Radio*. This was desired by Pius XI, inaugurated in 1931 by Guglielmo Marconi and was installed for the initial period (1931-1939) in Leo XIII's (1878-1903) Palazzina which he had built as a summer residence alongside the tower itself. Today the Radio studios face Castel S. Angelo and a large radio broadcasting Centre has been constructed 18 km. north of Rome, at Santa Maria di Galeria. Coming down from the Radio Tower along Leo IV's Wall one comes across the *Mater ecclesiae* monastery, desired by Pope John Paul II and inaugurated in 1994. This monastery houses a small community composed of some eight enclosed contemplative sisters of various Orders who alternate every five years.

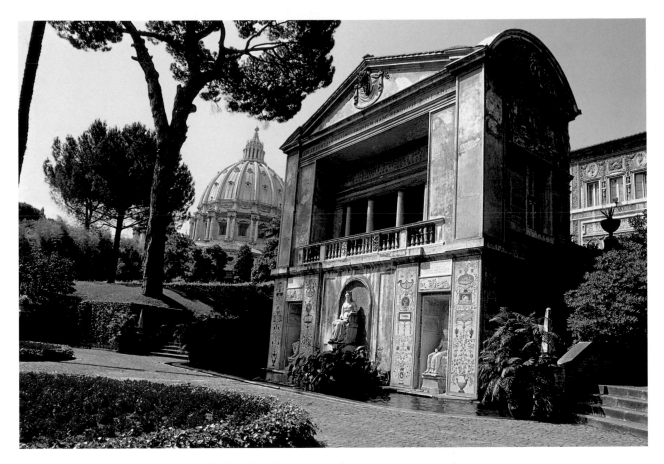

Vatican Gardens, Casina di Pio IV. The façade is decorated with mosaics, stuccoes and ancient statues.

The Order that inaugurated the first quinquennium was that of the Clarissans, in consideration of the fact that 1994 marked the eighth centenary of the birth of St. Clare in Assisi.

Wandering through the gardens one comes across many statues given to the Popes down through the years by Catholics from all over the world, such as the statue of *St. Peter in Chains*, or the polychrome ceramic of *Our Lady of Mercy*.

Of great religious value is the faithful reconstruction of the *Lourdes Grotto*, given in 1902 by French Catholics to Pope Leo XIII, an obligatory goal for the many pilgrims and tourists who come to visit the Gardens: the altar is the original one from Lourdes, transferred to the Vatican in 1958 on the occasion of the centenary of the apparition of Our Lady.

Vatican Gardens, Our Lady of Mercy of Savona, polychrome ceramic work of Renata Minuto.

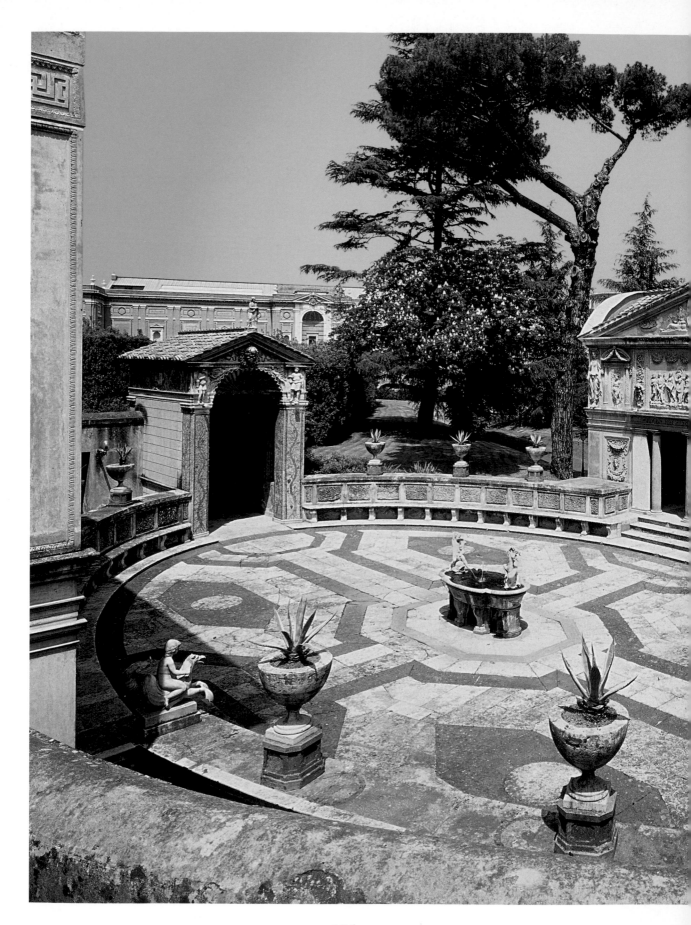

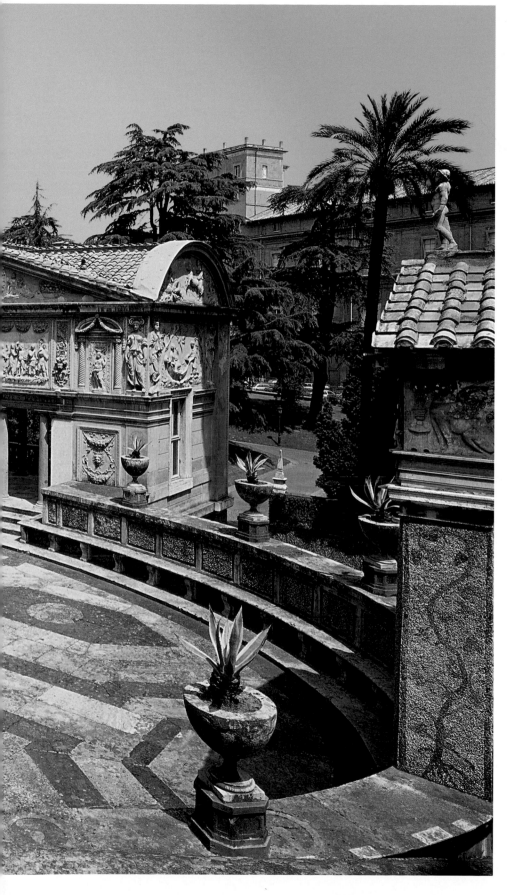

Casina di Pio IV Internal oval cortile also called the Ninfeo (Nymphaeum.).

Vatican Gardens. The Tower of the Radio.

Vatican Gardens. Detail of the Lourdes Grotto with the statue of Our Lady.

Notes

(1) With this treaty the old "Roman question" was resolved, following the Unification of Italy (1870), when the Church of Rome was deprived of those very intensive domains (including almost the entire present-day regions of Latium, Umbria and the Marches) that for centuries had made up the Pontifical State.

(2) In this year the famous fire spread throughout Rome and the Emperor attributed it to the Christians, thus giving him the pretext for proceeding with their persecution.

(3) This is the description of the plan of a basilica in which the vertical arm (the longitudinal nave) is longer than the transversal (the transept).

(4) Of fundamental importance is the precise information given to us by two "historical" guides that of Tiberio Alfarano of 1590 and that of Giacomo Grimaldi of 1619.

(5) This is how the plan of a basilica with four equal arms is described.

(6) In cupolas the tambour indicates the part of the structure with vertical sides on which the calotte is placed.

(7) Examined by distinguished scholars, the relic of the chair enclosed within Bernini's monument in reality turned out to be a throne of the Carolingian period donated by Charles the Bald to the Pope on the occasion of his coronation in St. Peter's in the year 875.

(8) The term Confessione (from the Latin verb "confitere" = to profess, to witness) indicates the area in which St. Peter was buried, the man who "confessed" his faith in God to the point of martyrdom.

(9) Thus called by archaeologists because of the colour of the plaster.

(10) This is the so-called *Capella Magna* mentioned in documents, but even today we still do not know if it was built (as would seem most probable) at the time of Urban V's return to Rome (1357) or, on the contrary, immediately after the transfer of the Popes to Avignon (1305).

(11) The Avignon exile (1309-1377), that determined the temporary transfer of the Holy See to Avignon, and the great Western Schism (1378-1417) which saw the coexistence of Popes and anti-Popes.

(12) By the term *lesena* (pilaster strip) is meant a prominence of the wall which in its simplest form appears devoid of base and capital or else in the form of a semipillar or semicolumn.

(13) By the term *grotesque* is meant a type of wall decoration with plant life and fantastic motifs that painters of the Renaissance took from those of the vaults, at that time half-buried (and for that reason called "grottoes"), of Nero's *Domus Aurea*.

(14) By *telamon* is understood an architectural structure in the form of a male figure acting as a column or pillar (the female figure that carries out the same function is known as a *caryatid*).

(15) Vitruvius, a Roman architect (1st century B.C.) is famous in that he is the author of ten books *De architectura* ("On architecture"), a compendium of architectural thinking of the classical period, which in subsequent times and especially during the Renaissance constituted a true and proper codex of reference in the architectural field.

(16) The decoration of the first floor of the loggias is owed to the hand of Raphael's pupil Giovanni da

Udine, while that of the third floor, the so-called Loggia della Cosmografia is later, (c. 1560), is attributed to Stefan du Perac and Giovanni Vanosino.

(17) Acquired by the then Cardinal Giuliano Della Rovere who displayed it in his residence near San Pietro in Vincoli, the Belvedere Apollo, was later transferred to the Vatican at the wish of the same Cardinal who had become Pope with the name of Julius II (1503-1513). The Laocoön group, discovered in the *Domus Aurea* in 1506, was acquired and inserted in the collection in the spring of that same year.

(18) A very serious loss for the artistic patrimony of the Vatican was the decision to proceed with the demolition of the *Cappella* of the Palazzetto del Belvedere, entirely frescoed by Andrea Mantegna which was razed to allow for the lengthening of the Galleria delle Statue.

(19) For *diritto di prelazione* (right of pre-emption) is understood, in juridical terms, the precedence accorded by law to a certain person in the purchase of a certain property.

(20) The various places where the collection of paintings was on temporary display were: Gregory XIII's wing on the third floor of the Loggias where it was transferred by Pius VII in 1822, the Galleria degli Arazzi where it was placed by Gregory XVI, to be moved then to the apartment of Pius V, Gregory XIII's wing was used once more under Pius IX (1857) and, finally, the first floor of the west corridor of the Cortile del Belvedere under Pius X (1909) when the collection had reached more or less the same number of paintings as it does at present.

(21) It is near Bramante's spiral stairway close to Innocent VIII's Palazzetto del Belvedere.

(22) This Latin couplet is engraved on a marble plaque attached to the side of the fountain.

Essential Bibliography

Bibliotheca Apostolica Vaticana, Florence: Nardini Editore, 1985.

Del Re, Niccolò (edited by), *Mondo Vaticano, passato e presente*, Vatican City: Libreria Editrice Vaticana, 1995.

Delfini Filippi, Gabriella, *San Pietro. La Basilica, La Piazza*, Rome: Fratelli Palombi Editori ("Guide del Vaticano", 1), 1989.

Delfini Filippi, Gabriella, *San Pietro. La Sagrestia, il Tesoro, Le Sacre Grotte, La Cupola, La Necropoli*, Rome: Fratelli Palombi Editori ("Guide dei Vaticano", 2), 1989.

Fallani, Giovanni – Escobar, Mario (edited by), *Vaticano*, Florence: Sansoni, 1946.

Galassi Paluzzi, Carlo, *La Basilica di San Pietro*, Bologna: Cappelli (*"Roma Cristiana"*, vol. XVII), 1975.

Il Vaticano e Roma cristiana. Vatican City: Libreria Editrice Vaticana, 1975.

Jung-Inglessis, Eva Maria, *San Pietro*, Florence: Istituto Fotografico Editoriale SCALA, 1980.

La Cappella Sistina. I primi restauri: la scoperta del colore, Novara: Istituto Geografico De Agostini, 1986.

La Cappella Sistina. La volta restaurata: il trionfo del colore, Novara: Istituto Geografico De Agostini, 1992.

La Città: parte occidentale, Rome: Fratelli Palombi Editori ("Guide del Vaticano", 3), 1989.

La Città: parte orientale, Rome: Fratelli Palombi Editori ("Guide del Vaticano, 4), 1989.

Mancinelli, Fabrizio, *La Cappella Sistina*, Vatican City: Edizioni Musei Vaticani, 1993.

Martin Jaques, *Vaticano sconosciuto*, Vatican City: Libreria Editrice Vaticana, 1990.

Natalini, Terzo – Pagano, Sergio – Martini, Aldo (edited by), *Archivio Segreto Vaticano*, Florence: Nardini Editore, 1991.

Pastor, Ludovico von, *Storia dei Papi dalla fine del Medio Evo*, Rome: Desclée & C. Editori Pontifici, 1932.

Pietrangeli, Carlo – De Strobel, Anna Maria, Mancinelli, Fabrizio (edited by), *La Pinacoteca Vaticana. Catalogo Guida*, Vatican City: Enel - Edizioni Musei Vaticani, 1993.

Pietrangeli, Carlo – Mancinelli, Fabrizio, *Vaticano, Città e Giardini*, Florence: Istituto Fotografico Editoriale SCALA, 1985.

Pietrangeli, Carlo (edited by), *Il Palazzo Apostolico Vaticano*, Florence: Nardini Editore, 1992.

Pietrangeli, Carlo, *I dipinti del Vaticano*, textes by Guido Cornini, Anna Maria De Strobel, Maria Serlupi Crescenzi, Udine. Magnus 1996.

Pietrangeli, Carlo, *I Musei Vaticani, Cinque secoli di storia*, Rome: Editions Quasar, 1985.

Raffaello nell'Appartamento di Giulio II e Leone X, Milan: Electa, 1993.

Redig De Campos, Deoclecio, *I Palazzi Vaticani*, Bologna: Cappelli, 1967.

Redig De Campos, Deoclecio, *Itinerario pittorico dei Musei Vaticani*, Rome: Lorenzo del Turco, 1964.

Vasari, Giorgio, *Le vite de' più eccellenti pittori scultori ed architetti*, Florence 1568.